BLUES MUSICIANS
OF THE
MISSISSIPPI DELTA

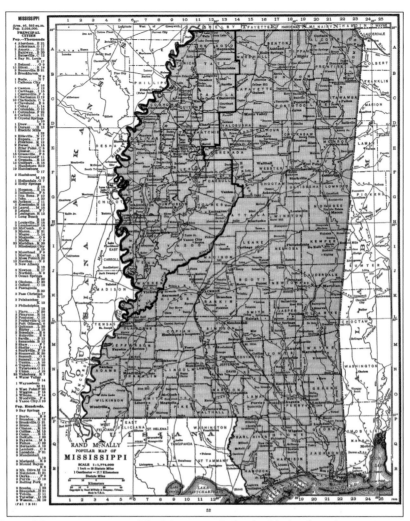

STATE MAP OF MISSISSIPPI, C. 1937. The Mississippi Delta, highlighted on this 1937 map, is located in the northwest section of Mississippi, between the Mississippi and Yazoo Rivers. The Delta is actually the floodplain of the Yazoo River. The Delta stretches 200 miles from the north at Memphis, to the south at Vicksburg. It reaches 87 miles across at its widest point. The Delta includes all or part of the following Mississippi counties: Bolivar, Carroll, Coahoma, DeSoto, Grenada, Holmes, Humphreys, Issaquena, Leflore, Panola, Quitman, Sharkey, Sunflower, Tallahatchie, Tate, Warren, Washington, and Yazoo. (Map by Rand McNally.)

FRONT COVER (clockwise from top left): Robert Lockwood Jr. (left) and Dave Myers at the Chicago Blues Festival in 1999 (Author's collection); David "Honeyboy" Edwards, Chicago Blues Festival, 1998 (Author's collection); James Cotton, Cleveland, Ohio, 1999 (Author's collection)

UPPER BACK COVER: Blue Front Café, Bentonia, Mississippi, 2017 (Author's collection)

LOWER BACK COVER (from left to right): B.B. King, Cleveland, Ohio, 1998 (Author's collection); Willie King, Chicago Blues Festival, 2000 (Author's collection); John Lee Hooker, Chesapeake Bay Blues Festival, 1999 (Author's collection)

BLUES MUSICIANS
OF THE
MISSISSIPPI DELTA

STEVEN MANHEIM

ARCADIA
PUBLISHING

Published by Arcadia Publishing
Charleston, South Carolina

Printed in the United States of America

Library of Congress Control Number: 2018956880

For all general information, please contact Arcadia Publishing:
Telephone 843-853-2070
Fax 843-853-0044
E-mail sales@arcadiapublishing.com
For customer service and orders:
Toll-Free 1-888-313-2665

Visit us on the Internet at www.arcadiapublishing.com

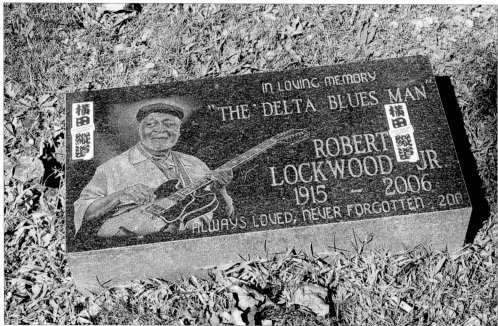

ROBERT LOCKWOOD JR. GRAVESITE, CLEVELAND, OHIO, 2018. Delta blues guitarist Robert Lockwood Jr. relocated with Sonny Boy Williamson II to Cleveland, Ohio, from Chicago in 1960. He became Cleveland's leading bluesman, playing regular gigs at Loving's Grill. In later years, he was a regular at Fat Fish Blue, Wilbert's, and Brothers Lounge, among others. He is buried at Riverside Cemetery in Cleveland. (Author's collection.)

CONTENTS

ACKNOWLEDGMENTS

Special thanks and recognition to Kelley Richards for her encouragement, support, and organizational skills with this book; Kristin Bauer for her belief in this project; Charles "D.C" Carnes for his vast musical knowledge, experience, and guitar work in the Robert Lockwood Jr. All-Star Band; and the Mississippi Blues Trail, created by the Mississippi Blues Commission, for installing detailed interpretive markers at historical sites. All photographs in this book are by the author.

INTRODUCTION

The blues is uniquely tied to the American experience. From the cotton fields of Mississippi to Delta street corners and juke joints to the big city lights of Chicago, the blues has made an indelible imprint on popular culture.

This book is a celebration to the spirit of the blues and a tribute to the great blues performers who created this music.

The primal urgency of the blues would resonate to create new American music called rock and roll in the 1950s. British rock bands of the 1960s were also inspired by this energy, incorporating it into their own music, bringing the blues full circle back to America.

The images in this book are a culmination of my journey documenting many of the great original blues performers, and the Delta land where they came from. As a lifelong aficionado of rock and blues and a former record-store owner, I have always been intrigued by where this music originated from.

Chicago and Delta blues innovator Robert Lockwood Jr. was my entry into blues photography. He was one of the last great Delta blues musicians. He allowed me to photograph him at his home in Cleveland, Ohio, on several occasions, and I took photographs of him at many club and festival locations.

As with Lockwood, many of the last great blues masters were nearing the end of their careers in the late 1990s into the 2000s. It was an important era to document them before they were gone. I photographed many of them at venues in Cleveland and at blues festivals in Chicago, Pennsylvania, Maryland, and Detroit.

During this time period, I compiled an extensive photographic catalog on color film of prominent musicians who were key in the development of the blues. Many of these performers were involved in the blues growth in the mid-20th century, an important era in American music.

Each of these musicians had unique life stories. Many of them overcame difficult childhoods and rough lives in the Delta fields. It was etched in the character on their faces and in the beat of their music.

Many of them came from the Mississippi Delta region. I was intrigued by the Delta, this alluring land that was the source of the blues. I took several driving tours through the Delta and greater Mississippi and photographed much of it in black and white film, rendering a gritty authenticity and realism to capture the mood.

There is an inseparable connection between the Delta blues and the land where it originated. The stark, austere landscapes and flat terrain projected an unusually beautiful yet unsettling calm. The remnants of once vibrant towns, many now filled with abandoned buildings and storefronts, had a sobering effect.

Small towns of mythic proportions like Itta Bena, Inverness, Shaw, Leland, Moorhead, Lula, Belzoni, Bentonia, Shelby and Tutwiler and the cities of Greenwood, Greenville, Helena, Clarksdale, Cleveland, Indianola, Jackson, and Vicksburg all contributed to the story of the blues.

The blues still resonates in the Delta through the music of blues greats Charley Patton, Son House, Muddy Waters, Elmore James, Willie Dixon, and B.B. King. It also echoes through lesser-known greats like Bukka White, Tommy Johnson, Sunnyland Slim, Skip James, Tommy McClennan, and Lonnie Johnson. The list is too long to do it justice.

The legacy of the legendary Robert Johnson continues to permeate the Delta. His 29 recorded songs set the benchmark for Delta blues and created the blueprint for Chicago blues and rock and roll. Tracing his mysterious life and untimely death remains an enigma.

Highway 61, the Blues Highway, along with Highway 49, are the main routes through the Delta. The mystique of these roads loom large in Delta folklore. Although the original routes have been replaced with modern highways, the sense of history still remains. The towns along these routes were essential in blues history, most famous in Clarksdale at the intersection of Highways 61 and 49. Beyond the crossroads legend, Clarksdale was an important city for the influx of blues influences.

Delta blues and the railroad culture remain forever linked. Railway themes were prevalent in the blues, representing travel or escape. Mississippi towns were connected by mainlines including the Yazoo and Mississippi Valley. The Illinois Central took multitudes out of the Delta during the Great Migration of the early to mid-20th century.

The blues migrated along with African Americans to Chicago, St. Louis, and Detroit and other Northern cities. Delta blues were transformed into electric Chicago blues, the forerunner to rock and roll. The blues influence came to fruition with the first rock-and-roll records made at Sun Records in Memphis.

The blues comes from deep within the soul, cutting straight to the emotional core. It can roar like a freight train or cascade like a country steam. It speaks to the truth when no justice can be found. The blues evokes all these feelings and images.

The blues speaks to life, the blues is life.

RECOMMENDED LISTENING

Carey Bell, *Good Luck Man*, Alligator Records, 1997
Big Bill Broonzy, *The Anthology*, Not Now Music, 2011
R.L. Burnside, *My Black Name A Ringin'*, Adelphi Records, 1999
R.L. Burnside, *Too Bad Jim*, Fat Possum, 2005
Eddy Clearwater, *Reservation Blues*, Bullseye, 2000
James Cotton, *Mighty Long Time*, New West Records, 2015
Jimmy Dawkins, *Fast Fingers*, Delmark, 1998
David "Honeyboy" Edwards, *The World Don't Owe Me Nothing*, Earwig Music, 1997
John Lee Hooker, *The Very Best of*, Rhino, 1995
Howlin' Wolf, *His Best: Chess 50th Anniversary Collection*, MCA/Chess, 1997
Little Milton, *Greatest Hits: Chess 50th Anniversary Collection*, MCA/Chess, 1997
Son House, *The Original Delta Blues*, Columbia/Legacy, 1998
Mississippi John Hurt, *The Complete Recordings*, Vanguard, 2000
Elmore James, *The Sky Is Crying: The History of Elmore James*, Rhino, 1993
Big Jack Johnson, *All the Way Back*, M.C. Records, 1998.
Robert Johnson, *The Complete Recordings*, Columbia, 1990
Albert King, *Very Best of*, Rhino, 1999
B.B. King, *Live at the Regal*, MCA, 1997
B.B. King, *Indianola Mississippi Seeds*, MCA, 2005
B.B. King, *Completely Well*, MCA, 1998
Robert Lockwood Jr., *Delta Crossroads*, Telarc, 2000
Robert Lockwood Jr., *Steady Rollin' Man*, Delmark, 1993
Charlie Patton, *The Best of*, Yazoo Records, 2003
John Primer, *Stuff You Got To Watch*, Earwig Music, 1992
Jimmy Reed, *The Very Best of Jimmy Reed*, Rhino, 2000
Otis Rush, *The Essential Otis Rush: Classic Cobra Recordings 1956–1958*, Fuel 2000, 2000
Muddy Waters, *His Best: 1947 to 1955*, MCA/Chess, 1997
Sonny Boy Williamson, *His Best: Chess 50th Anniversary Collection*, MCA/Chess, 1997

One

THE LAST OF THE GREAT MISSISSIPPI DELTA BLUES MUSICIANS

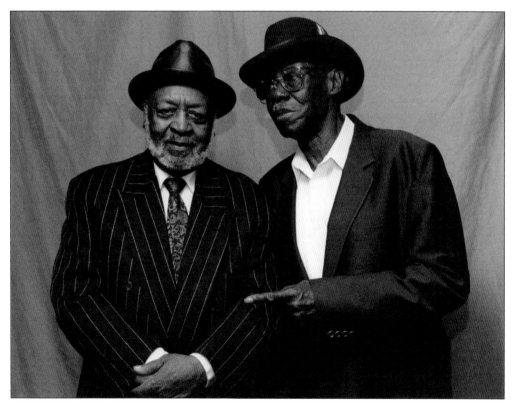

ROBERT LOCKWOOD JR. AND PINETOP PERKINS, CLEVELAND, OHIO, 1998. Robert Lockwood Jr. (left) and Joe Willie "Pinetop" Perkins were two of the last great Delta blues musicians. They both appeared on *King Biscuit Time*, a live radio program in the 1940s on KFFA in Helena, Arkansas. Lockwood, on electric guitar, played with harp great Sonny Boy Williamson II in 1941. Perkins later joined the original band on piano. This program was the first to broadcast live blues heard throughout the Mississippi Delta region.

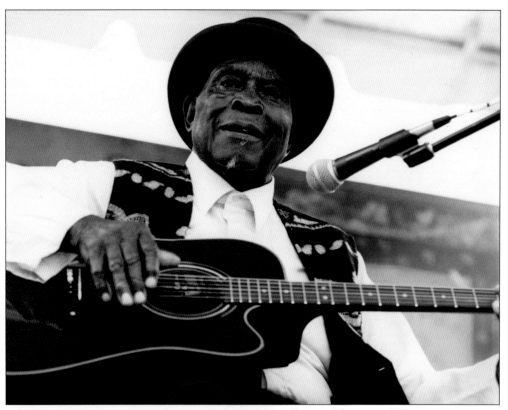

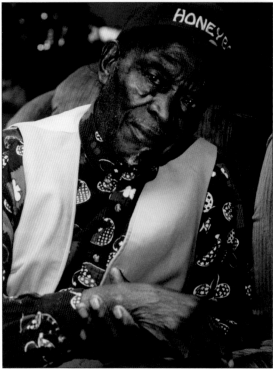

DAVID "HONEYBOY" EDWARDS, CHICAGO, 1998, AND CLEVELAND, OHIO, 2000. Throughout his 80-year career, David "Honeyboy" Edwards was the embodiment of the rambling, itinerant blues musician. Born in Shaw, Mississippi, in 1915, he remained true to the original Delta blues style. He learned to play from his father, Henry Edwards, and blues pioneers Charley Patton and Tommy Johnson. He traveled throughout the South playing in juke joints with Robert Johnson, Big Joe Williams, Tommy McClennan, Sonny Boy Williamson II, and Big Walter Horton. He was with Robert Johnson on the night of his final performance in August 1938, when Johnson was allegedly poisoned in Greenwood, Mississippi. Folklorist Alan Lomax recorded him in 1942 for the Library of Congress in Clarksdale. Edwards continued to tour well into his nineties, carrying the torch for the Delta blues into the 21st century.

JOHN LEE HOOKER, CHESAPEAKE BAY BLUES FESTIVAL, 1999. John Lee Hooker, "the King of the Delta Boogie," was one of the blues' most influential performers. His pulsating, rhythm-based guitar and distinctive vocals resonated with blues and rock audiences for six decades. Hooker was born to sharecroppers near Clarksdale, Mississippi, in 1917, although there are contradictory details about his early life. His father was a preacher, and spiritual music was his early influence. At age 14, he ran away to live with his stepfather Will Moore, a blues musician, who was a major factor in his playing style. By the early 1940s, Hooker moved to Detroit, by way of Memphis and Cincinnati. In 1948, he released his seminal debut "Boogie Chillen." The hypnotic-grooves on "Crawlin' Kingsnake," "I'm in the Mood," and "Boom Boom" struck a chord with British rock bands in the 1960s, helping fuel the British Invasion and a blues resurgence in America.

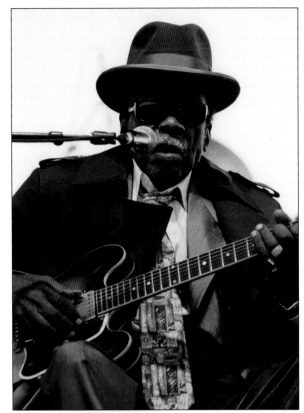

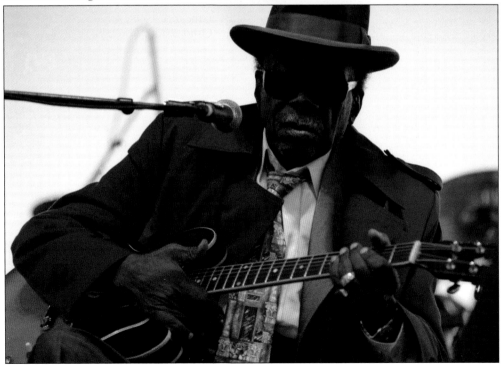

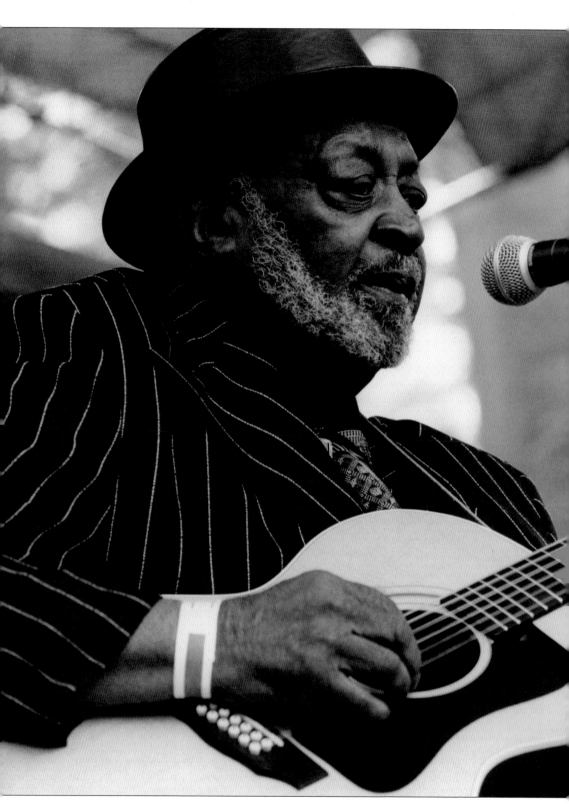

ROBERT LOCKWOOD JR., CHICAGO, 1999.
Robert Lockwood Jr. was a blues innovator and one of the last great Delta blues musicians. A pioneer in the development of electric guitar, he introduced a jazzy inflection with more complex chord structures into the blues. Born in 1915 on a farm in Turkey Scratch, Arkansas, near Helena, Lockwood was a direct link and the only student of the legendary Robert Johnson, who was his stepfather. He made his first recordings on Bluebird in 1941. He was the first electric guitarist to be heard on live radio in the Delta, playing on *King Biscuit Time* with Sonny Boy Williamson II in 1941 on KFFA in Helena, Arkansas. Lockwood was a well-known session player in Chicago in the 1950s for Sonny Boy Williamson II, Little Walter, Willie Dixon, and Otis Spann. He was a mentor to B.B. King and the Delta's first modern lead guitar player. He was inducted into the Blues Hall of Fame in 1989.

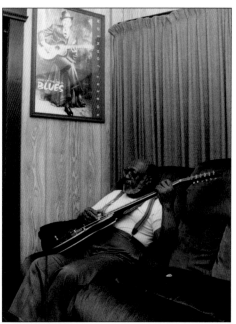

ROBERT LOCKWOOD JR. AT HOME, CLEVELAND, OHIO, 1998. Robert Lockwood Jr. patterned his early style on Robert Johnson's playing intricacies in the 1930s. He took Johnson's intense polyrhythmic style and incorporated jazz elements, creating his own unique phrasing of traditional blues. His blues standards include "Little Boy Blue," "Take a Little Walk With Me," and "Black Spider Blues."

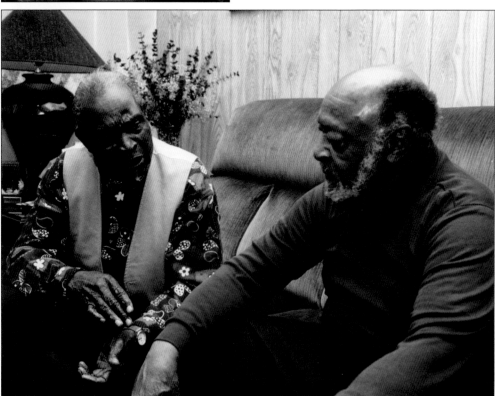

HONEYBOY EDWARDS AND ROBERT LOCKWOOD JR., CLEVELAND, OHIO, 2000. David "Honeyboy" Edwards (left) and Robert Lockwood Jr. were two of the last great Delta blues musicians, both with direct links to the legendary Robert Johnson. Edwards played and traveled with Johnson in the Mississippi Delta in the 1930s. They both relocated to Chicago in the 1950s.

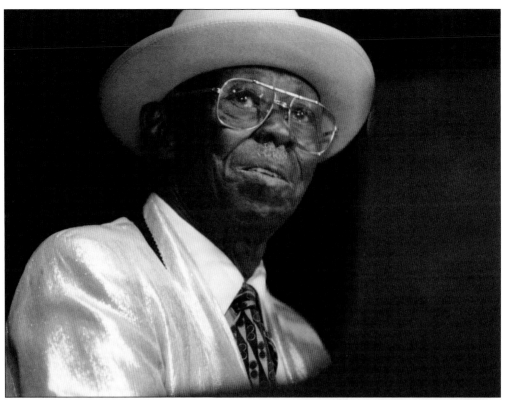

PINETOP PERKINS, POCONO BLUES FESTIVAL, 1999, AND CLEVELAND, OHIO, 1998. Joe Willie "Pinetop" Perkins was one of the blues' greatest pianists. His boogie-woogie, barrelhouse style made him one of the blues' best modern piano players. He was born in 1913 in Belzoni, Mississippi, where he worked in plantation cotton fields. A knife attack severed tendons in his arm in 1943, forcing him to switch from guitar to piano. Perkins traveled to Helena, Arkansas with Robert Nighthawk in 1943, where he played on the *King Biscuit Time* radio show on KFFA with Sonny Boy Williamson II. "Pinetop's Boogie Woogie," recorded at Sun Records in 1953, became Perkins's signature tune. The original version was done by Pinetop Smith in 1928. His session work included Nighthawk, Earl Hooker, Little Milton, and Albert King. He replaced Otis Spann for a stint in Muddy Waters's last great band in 1969. He won a Grammy Award for "Joined at the Hip" with Willie "Big Eyes" Smith in 2011.

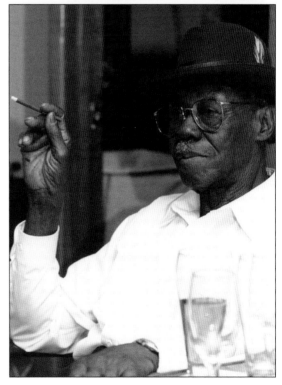

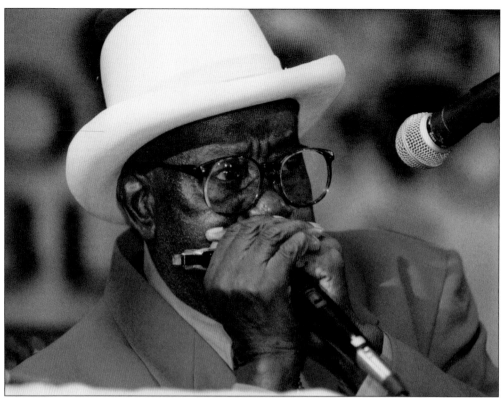

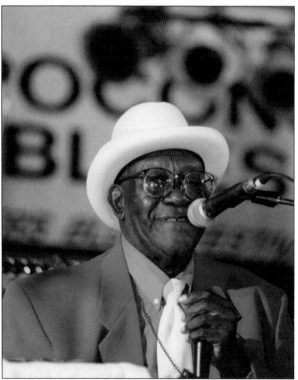

SNOOKY PRYOR, POCONO BLUES FESTIVAL, 1999. James Edward "Snooky" Pryor was a pioneer in amplified Chicago blues harmonica. Born in Lambert, Mississippi, in 1921, he began playing harmonica as a child. Pryor developed his piercing style in the Delta before moving to Chicago in 1940. He is believed to be the first harp player to amplify his sound by cupping a harmonica and microphone in his hands through a public address (PA) system. Influenced by Sonny Boy Williamson and Sonny Boy Williamson II, Pryor made important 78s during the postwar Chicago blues era. Along with guitarist Moody Jones, he recorded "Telephone Blues" and "Boogie" in 1948. He also played in Chicago with Homesick James, Eddie Taylor, and Floyd Jones.

HENRY TOWNSEND, CHICAGO BLUES FESTIVAL, 1999. Henry Townsend has the distinction of being the only blues musician to have recorded in every decade from the 1920s through the 2000s. He made his first recording in 1929 and was on many major labels of his time including Paramount, Columbia, Bluebird, and Brunswick. Born in 1909 in Shelby, Mississippi, he moved to St. Louis in his teens, where he became an in-demand session player on guitar and piano. His playing was influenced by pianist Roosevelt Sykes and guitarist Lonnie Johnson. Townsend was an integral part of the St. Louis blues scene from the 1920s through 1940s, helping make the city a blues center in the pre–World War II years. His final recording was in 2006 on the Grammy Award–winning *The Last of the Great Delta Bluesmen*, with David "Honeyboy" Edwards, Robert Lockwood Jr., and Pinetop Perkins.

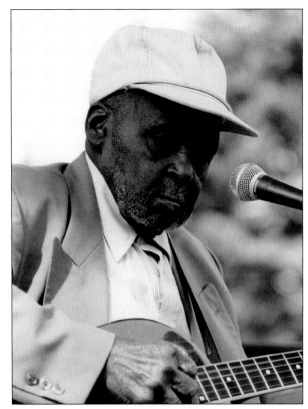

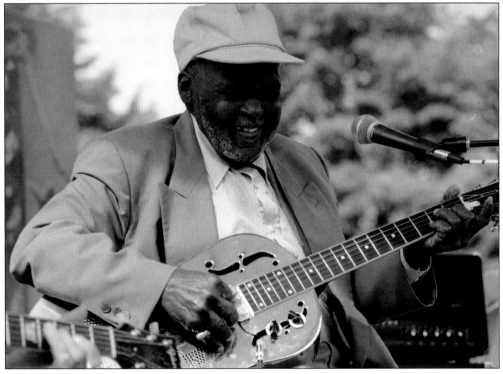

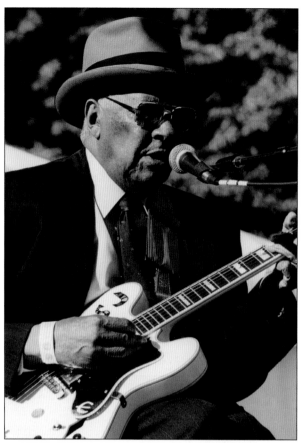

HOMESICK JAMES, CHICAGO BLUES FESTIVAL, 2000. Homesick James Williamson was a preeminent blues slide guitar player and a fixture on the Chicago scene in the 1950s. Born in Somerville, Tennessee, in 1910, he was also known as John William Henderson, adding to the many discrepancies about his early life. He claimed to have played in the South with Yank Rachell, Sleepy John Estes, Blind Boy Fuller, and Big Joe Williams. He also claimed to be a cousin to slide guitar great Elmore James, who greatly influenced his playing style. He was a member of James's band in Chicago from 1955 to 1963. He played on the essential Elmore James's recordings of "Dust My Broom," "The Sky Is Crying," and "Rollin' and Tumblin'." He also worked with Sonny Boy Williamson II, Snooky Pryor, Floyd James, and "Baby Face" Leroy Foster in Chicago. He recorded into the 1990s, making festival appearances into the 2000s, while in his 90s.

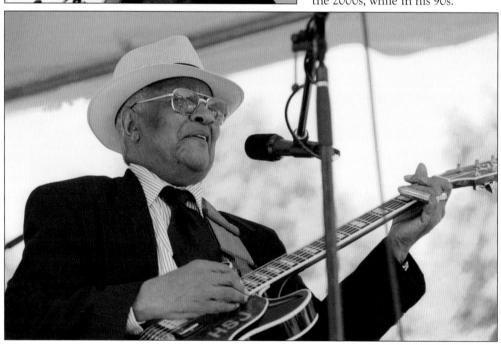

Two

Blues Musicians of the Delta and Mississippi

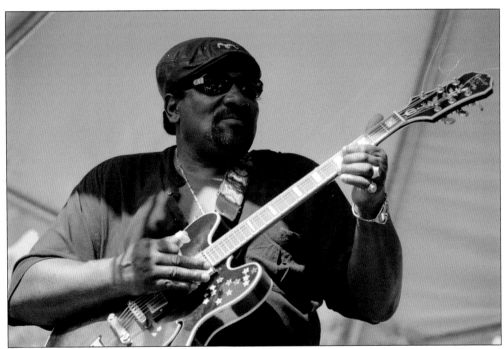

Big Jack Johnson, Chicago Blues Festival, 1999. The Mississippi Delta is the traditional home of the blues and the birthplace to many of the greatest performers in blues history. While most of these performers would relocate to cities like Chicago, Big Jack Johnson stayed in the Delta, where he played authentic Delta blues in his hometown of Clarksdale, Mississippi.

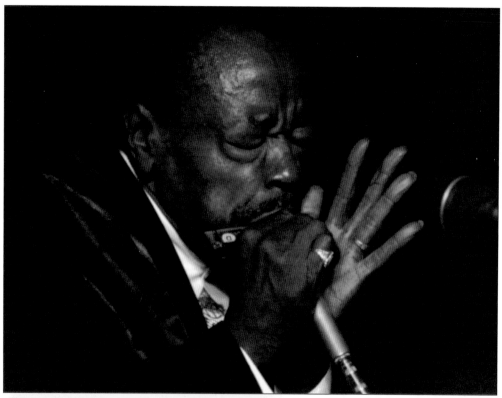

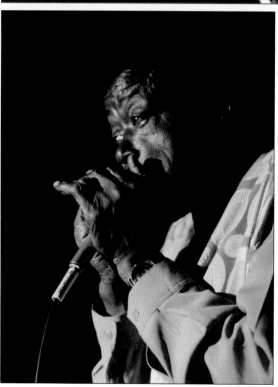

CAREY BELL, CLEVELAND, OHIO, 1998 (ABOVE) AND 1999 (LEFT).
Carey Bell was among Chicago's greatest blues harp players. Born Carey Bell Harrington in Macon, Mississippi, in 1936, he was self-taught on harmonica, influenced by Big Walter Horton, Little Walter Jacobs, Sonny Boy Williamson, and Sonny Boy Williamson II (Rice Miller). He integrated these influences into his own thick, distinctive signature. He played with his godfather, pianist Lovie Lee, at age 13, who brought him to Chicago in 1956. He performed in bands with Muddy Waters and Willie Dixon in the late 1960s and early 1970s before starting a solo career. He modernized his approach with a more contemporary rhythm feel in later years. *Harp Attack*, a collaboration with Bell, James Cotton, Junior Wells, and Billy Branch, was released in 1990.

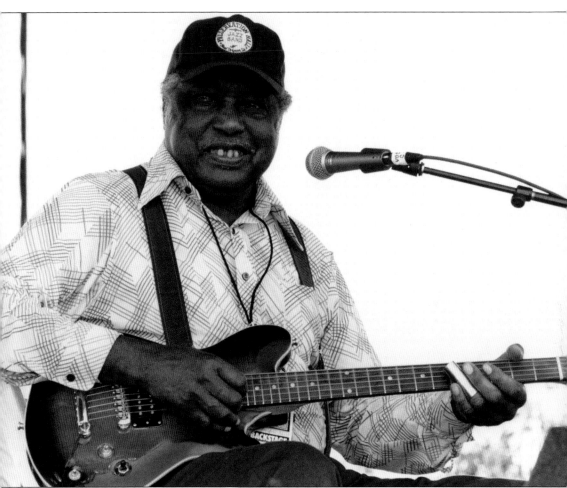

R.L. Burnside, Chesapeake Bay Blues Festival, 1999. R.L. Burnside played a raw, rhythmic juke-joint-inspired blues. Born in Harmontown, Mississippi, in 1926, he lived most of his life in the North Mississippi hill country, just east of the Delta. He learned country blues from his neighbor, Mississippi Fred McDowell, and was influenced by John Lee Hooker, Muddy Waters, and Lightnin' Hopkins. After a short stay in Chicago in the late 1940s, he returned to Holly Springs, Mississippi, where he was a farmer and fisherman into the mid-1980s. He was first recorded in the field by George Mitchell in 1967. He played his gritty, hypnotic-groove blues in the hill country, releasing his debut album, *Bad Luck City*, in 1992. He enjoyed a popular resurgence among blues and rock fans in the 1990s who appreciated his earthy, down-home style.

ARON BURTON, CHICAGO BLUES FESTIVAL, 2000. For over 50 years, Aron Burton was a longtime in-demand bass player in Chicago. Born in 1938 in Senatobia, Mississippi, his musical foundation was formed by early exposure was to gospel and blues. He moved to Chicago in 1955, playing backup for Freddie King and Junior Wells. Burton was a session player for Johnny Littlejohn, James Cotton, and Fenton Robinson and was an original member of Albert Collins's Icebreakers in 1978. He released several solo albums in the 1990s.

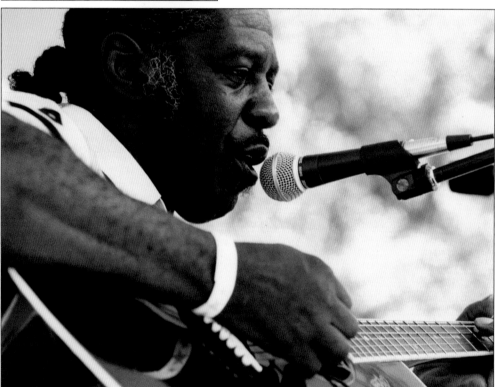

EDDIE C. CAMPBELL, CHICAGO BLUES FESTIVAL, 1999. Longtime Chicago blues veteran Eddie C. Campbell played among the best of Chicago's West Side. Born to sharecroppers in 1939 in Duncan, Mississippi, he learned guitar in the 1950s from Magic Sam and Luther Allison. He worked as a sideman for Howlin' Wolf, Little Walter, Little Johnny Taylor, and Jimmy Reed and toured with Otis Rush and Mighty Joe Young. After living for nearly a decade in Europe, he returned to Chicago in 1992.

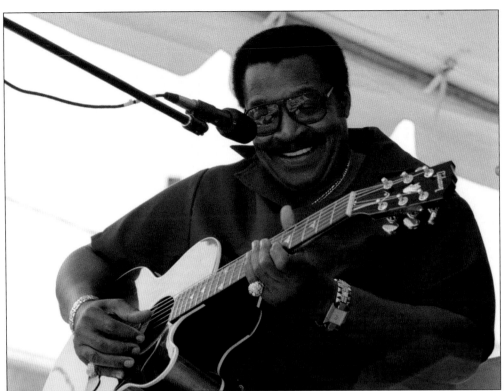

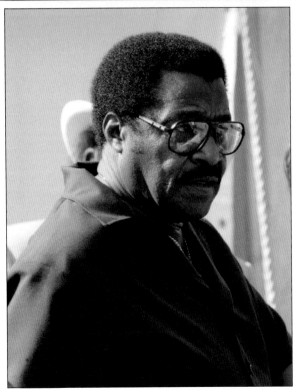

LITTLE MILTON, CHICAGO BLUES FESTIVAL, 1999. Little Milton combined an energetic blend of blues, soul, and R&B over his five-decade career. Born James Milton Campbell in 1934 to sharecroppers in Inverness, Mississippi, he was raised in Greenville by his musician father, Big Milton Campbell. He took on the name "Little Milton" to distinguish himself from his father. Ike Turner recommended him to Sam Phillips at Sun Records, where Milton made his first recording in 1953. Little Milton's R&B breakthrough, "We're Gonna Make It," resonated during the civil rights movement in 1965. He had a string of top-10 hits at Chess, including "Grits Ain't Groceries" and "If Walls Could Talk," along with recording stints at Stax and Malaco Records. He was inducted into the Blues Hall of Fame in 1988.

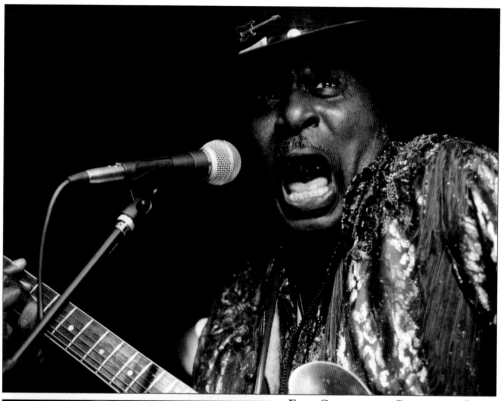

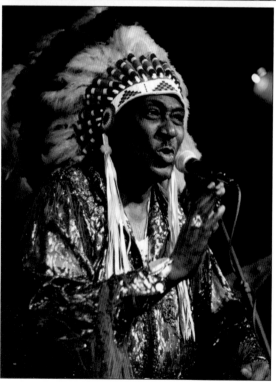

EDDY CLEARWATER, CLEVELAND, OHIO, 2000. Eddy "the Chief" Clearwater was a forerunner in Chicago's West Side guitar blues. Born Edward Harrington in 1935 in Macon, Mississippi, he left for Chicago in 1950. He was a cousin to harp great Carey Bell, also from Macon. His musical influences ranged from gospel, rockabilly, country, blues, and rock. In Chicago, he was a student of "Magic Sam" Maghett. He took the name "Clearwater" as a play on the name Muddy Waters, and his nickname "the Chief" was adopted from his Cherokee heritage. Clearwater's high-energy shows meshed the exuberance of 1950s rock and roll with Chicago blues. His full Indian headdress was always a show highlight. He was inducted into the Blues Hall of Fame in 2016.

James Cotton, Chicago Blues Festival, 1998, and Cleveland, Ohio, 1999. James Cotton was one of the last links between the Delta blues and Chicago blues traditions. Born on a cotton farm in Tunica, Mississippi, in 1935, he was influenced and taught by harmonica great Sonny Boy Williamson II. Cotton's first records were "Straighten Up Baby" and "Cotton Crop Blues" for Sam Phillips on Sun Records in 1953. He replaced Little Walter in Muddy Waters's band and was the last great harp player in his band. Dubbed "Mr. Superharp," he started his solo career in 1966, forming the James Cotton Blues Band. His high-energy playing and reputation appealed to the blues-rock crowd, where he worked with B.B. King, Janis Joplin, Gregg Allman, Johnny Winter, and the Grateful Dead, among others.

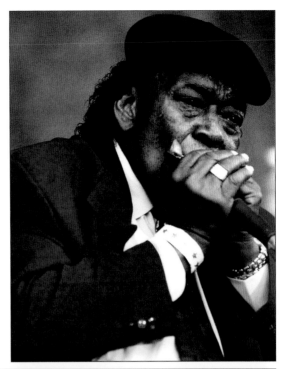

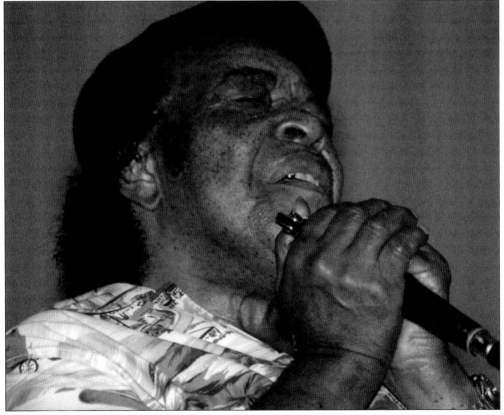

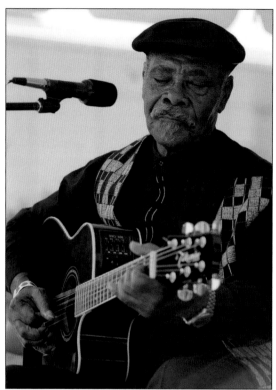

EDDIE CUSIC, CHICAGO BLUES FESTIVAL, 2000. Eddie Cusic was one of the last true country blues musicians in the Delta. Raised in a farming family, he was inspired by hearing blues played during get-togethers in his local community. Born in 1926 in Wilmot, Mississippi, near Leland, Cusic first learned on a "diddly-bow," a one-string instrument consisting of a piece of baling wire attached to a wall and played with a knife or bottleneck. He formed the Rhythm Aces in the early 1950s and was an early mentor to Little Milton Campbell. Cusic performed with Delta blues great James "Son" Thomas in the 1970s. A quarry worker by day, he played local juke joints at night in Greenville and Leland. He released his first album, *I Want to Boogie*, in 1998.

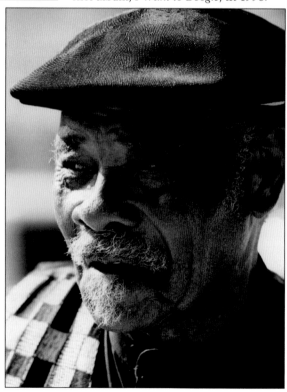

TYRONE DAVIS, CLEVELAND, 1998.
Tyrone Davis was one of Chicago's greatest soul singers. His baritone range included classic soul, funk, and R&B. Born Tyrone Fettson on a plantation near Leland, Mississippi, in 1938, he spent his formative years in Michigan before moving to Chicago in 1959. While working as a chauffeur for Freddie King, he performed in Chicago clubs. Davis had three number one R&B hits: "Can I Change My Mind," "Turn Back the Hands of Time," and "Turning Point."

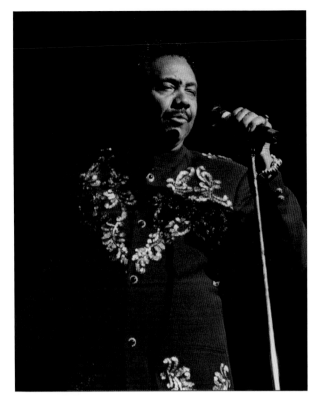

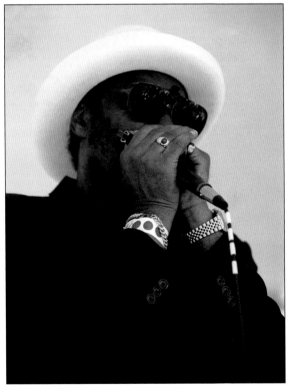

LESTER DAVENPORT, CHICAGO BLUES FESTIVAL, 1999. Lester "Mad Dog" Davenport was a veteran Chicago blues harp session player. Born in 1932 in Tchula, Mississippi, he played with Snooky Pryor, Homesick James, and Arthur "Big Boy" Spires and is heard on a pair of Bo Diddley's Chess recordings from 1955. His credits include sessions with Jimmy Dawkins, Aron Burton, Johnnie B. Moore, Bonnie Lee, and Willie Kent. He was a member of the Kinsey Report in the 1980s.

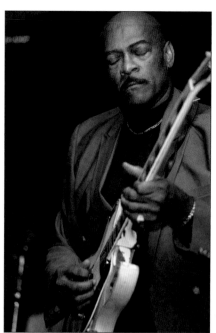

JIMMY DAWKINS, CLEVELAND, OHIO, 1998. Jimmy Dawkins was an important exponent of Chicago's "West Side Sound," a slicker, less hard-edged blues than the South Side blues of Muddy Waters and Howlin' Wolf. Born in 1936 in Tchula, he grew up in Pascagoula, Mississippi, before arriving in Chicago in 1955. He gained notice on "Chicago Blues" with Johnny Young and Big Walter Horton in 1967 and toured in the Otis Rush band in the early 1970s. His introspective lyrics, combined with soulful guitar and vocals, rank among Chicago's best. He was popular in Europe, France, and Japan.

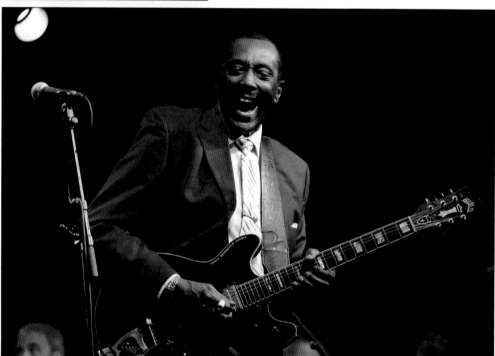

TRAVIS HADDIX, CLEVELAND, OHIO, 2018. Travis "Moonchild" Haddix blends Southern soul and R&B, reminiscent of the 1960s Stax/Volt era, into his own style of contemporary blues. Born to sharecroppers in 1938 in Hatchie Bottom, Mississippi, he moved to Walnut at age nine, where he was taught guitar by his father, Chalmus "Rooster" Haddix. He was inspired by B.B. King on WDIA in Memphis. After moving to Milwaukee, he relocated to Cleveland in 1963, where he continues to play local clubs, along with concerts and festivals.

BIG JACK JOHNSON, CLEVELAND, OHIO, 1998 (RIGHT), AND AKRON, OHIO, 1999. Big Jack Johnson played a raw, electrified version of the Delta blues. Born the son of a sharecropper in Lambert, Mississippi in 1939, he was a longtime fixture in the Clarksdale blues scene. His father, Ellis Johnson, was a fiddler and an early musical inspiration. When not on tour, Johnson considered Red's Blues Club in Clarksdale as his home base. He played authentic juke-joint blues as a member of the Delta's iconic Jelly Roll Kings with Frank Frost and Sam Carr in the 1970s and 1980s. He embarked on a solo career in 1987 with *The Oil Man*, which infused energetic contemporary blues and social commentary. These were themes that would continue throughout his career. He got his nickname "the Oil Man" as a driver for Rutledge Oil Co. before he made music as a full-time career.

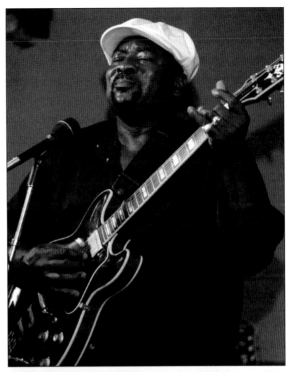

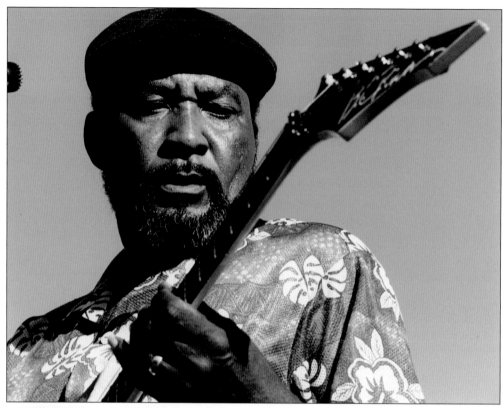

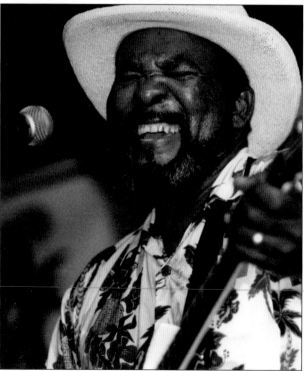

SUPER CHIKAN, CHICAGO BLUES FESTIVAL (ABOVE) AND ROSA'S, CHICAGO, 2000. James "Super Chikan" Johnson blends a mix of blues, rock, funk, soul, and country into his modern take on Delta blues. Born in Darling, Mississippi, in 1951, and based in Clarksdale, Super Chikan got his unique name by working with chickens on his family farm. His funky, down-home blues was influenced by Muddy Waters, John Lee Hooker, Chuck Berry, and his cousin Big Jack Johnson. His lyrics infuse both humorous and serious views on contemporary life in the Delta, making him one of the last Delta blues originals. Johnson worked as a cab driver, truck driver, and tractor driver before becoming a full-time musician in his 40s. His debut album, *Blues Come Home to Roost*, was released in 1997.

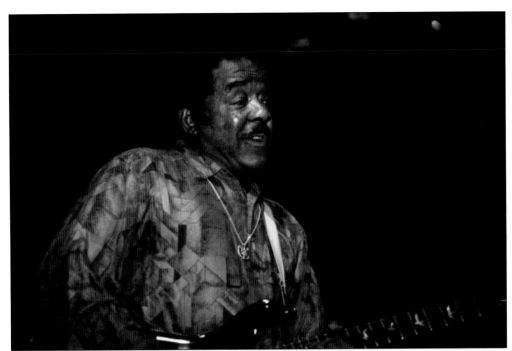

JIMMY JOHNSON, CHICAGO, 1999.
Jimmy Johnson worked alongside many blues and R&B greats in the 1960s, including Otis Clay, Denise LaSalle, and Garland Green. He returned to the blues with Jimmy Dawkins and Otis Rush in the mid-1970s. Born into a musical family in 1928 in Holly Springs, Mississippi, he released his first full solo album when he was 50 years old. His album *Bar Room Preacher* from 1983 was a gritty blues masterwork.

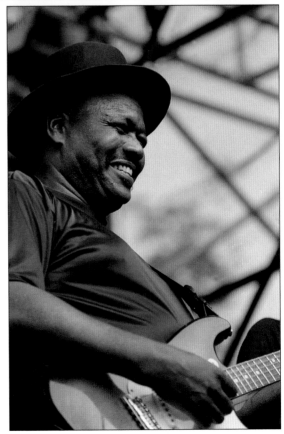

JOHNNY JONES, POCONO BLUES FESTIVAL, 2000. Longtime Chicago and Detroit blues veteran Johnny "Yard Dog" Jones recorded his first album at age 55 in 1996. Born on a cotton plantation in Crawfordsville, Arkansas, in 1941, he relocated to East St. Louis, Illinois, before moving to Chicago at age 18. He was inspired by the soul music of O.V. Wright and Johnnie Taylor, who was also a Crawfordsville native. He took on the nickname "Yard Dog" to gain more exposure.

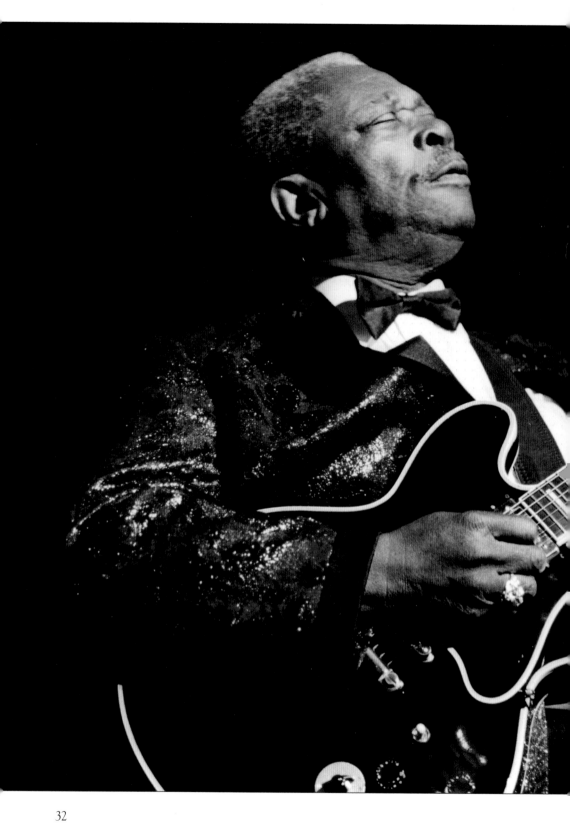

B.B. KING, CLEVELAND, OHIO, 1998. Riley B. "B.B" King, "the King of the Blues," is among the most important and influential figures in blues music history. His impact on the evolution of blues and rock music is incalculable. His crisp, staccato guitar phrasing and passionate vocals blended seamlessly, creating a unique and powerful combination. Born on a plantation in 1925 in Berclair, Mississippi, in Leflore County, he became immersed in the Delta blues, including the blues of his cousin Bukka White, before moving to Memphis. It was there where he became known as the "Beale Street Blues Boy," or B.B. for short, on a radio show he did on WDIA in Memphis in 1949. His first record, "Three O'Clock Blues," recorded at Sun Records in 1951, launched his career. His long string of R&B hits in the 1950s included "You Upset Me Baby," "Sweet Little Angel," and "Everyday I Have the Blues." His *Live at the Regal* from 1964 is considered one of the great live blues guitar albums, influencing many blues and rock guitarists. King became popular with the rock music crowd with blues festival appearances in the late 1960s. His version of Roy Hawkins's "The Thrill Is Gone" became a crossover hit in 1969. He won 15 Grammy Awards and was inducted into the Blues Hall of Fame in 1984 and Rock and Roll Hall of Fame in 1987.

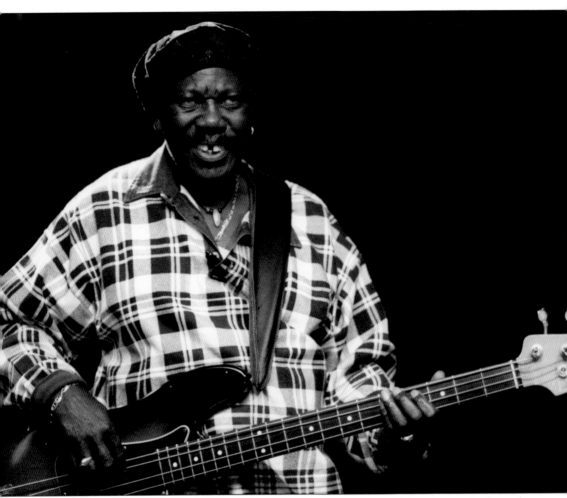

WILLIE KENT, CLEVELAND, OHIO, 2000. Willie Kent was one of Chicago's premier bass players and one of the last links to the great Mississippi Delta blues tradition. He played with many blues greats including Muddy Waters, Howlin' Wolf, Little Walter, and Junior Parker. Born to sharecroppers in Inverness, Mississippi, in 1936, he was exposed at a young age to gospel and blues. As a teen, he listened to *King Biscuit Time* on KFFA in Helena and absorbed the blues on arrival in Chicago in 1952. He was a member of bands with Little Milton and Jimmy Dawkins before taking Dawkins's regular spot at Ma Bea's Lounge on Chicago's West Side. His band, Willie Kent and His Gents, was a regular feature in Chicago for nearly 20 years. He recorded eight albums and received recognition with a W.C. Handy award in 1995.

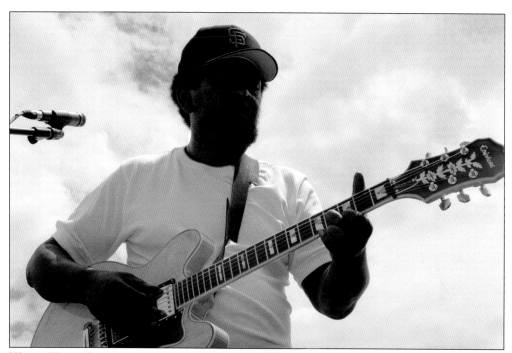

WILLIE KING, CHICAGO BLUES FESTIVAL AND ROSA'S, CHICAGO, 2000. Willie King played raw, juke-joint blues in Mississippi and Alabama. Born in Prairie Point, Mississippi, in 1943, he was raised by sharecropper grandparents. After a short stay in Chicago, where he was influenced by Muddy Waters, Howlin' Wolf, and John Lee Hooker, he returned to Old Memphis, Alabama, near the Mississippi border. He became involved in the civil rights movement in the late 1960s, inspired by activist performers including Josh White, Joan Baez, and Pete Seeger. King played his rocking, hypnotic-groove "struggle blues" in local juke joints and recorded a series of albums in the 2000s.

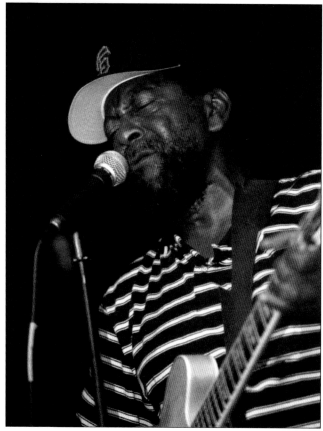

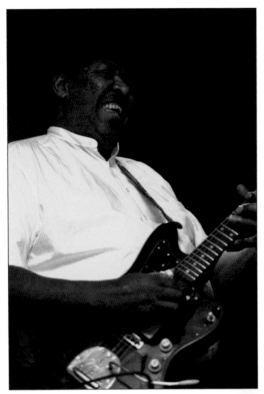

MAGIC SLIM, CLEVELAND, OHIO, 2000.
Magic Slim played a gritty, urban Chicago blues reminiscent of Howlin' Wolf and Muddy Waters of the 1950s. Slim, whose real name was Morris Holt, established himself in Chicago in the mid-1960s. Born to sharecroppers in 1937 in Torrance, Mississippi, near Grenada, he lost the little finger on his right hand to a cotton gin, forcing him to switch from piano to guitar. He got his nickname from friend and mentor "Magic Sam" Maghett of Grenada. Both moved to Chicago in the mid-1950s. He returned to Mississippi to hone his craft before heading back to Chicago to make his first recording in 1966. He took over for Hound Dog Taylor at Florence's on Chicago's South Side. Magic Slim and the Teardrops kept the Delta tradition alive with an eclectic version of Chicago blues. He was inducted into the Blues Hall of Fame in 2017.

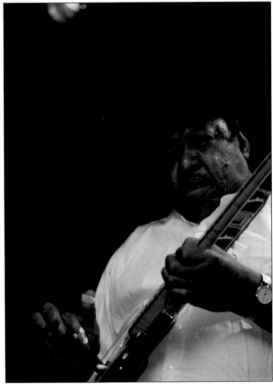

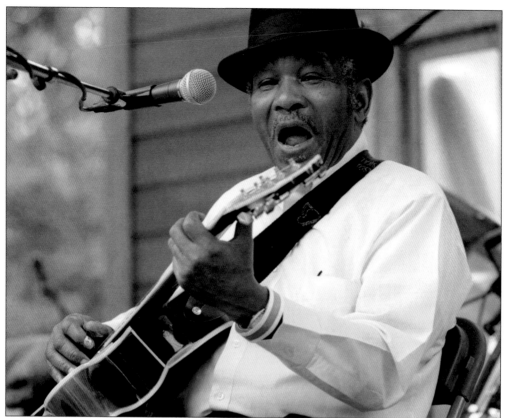

Dave Myers, Chicago Blues Festival, 1999. Dave Myers, along with his brother Louis, formed the Aces, the first electric blues band in Chicago. The Aces were originators of the classic Chicago blues sound in the late 1940s. Born in Byhalia, Mississippi in 1926, Myers learned to play guitar from Lonnie Johnson as a youth. The Aces played behind Jimmy Reed, Roosevelt Sykes, Billy Boy Arnold, Louis Jordan, Jimmy Rogers, Robert Lockwood Jr., and Eddie Taylor. Junior Wells was a member of the Aces before joining Muddy Waters. Myers was the first electric bassist in Chicago and a noted session player for Earl Hooker, Otis Rush, and Little Walter. The Aces were inducted into the Blues Hall of Fame in 2018.

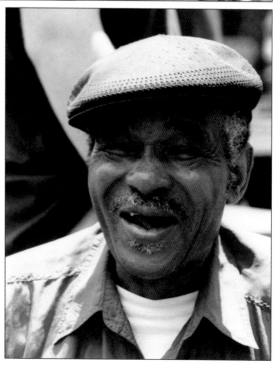

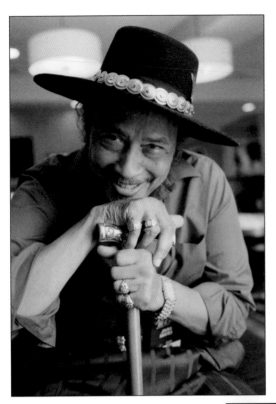

JIMMI MAYES, INDIANOLA, MISSISSIPPI, 2016. Chicago drummer Jimmi Mayes has played alongside a who's who of the greatest musicians in history. Best known as "Sideman to the Stars," Mayes has worked with Marvin Gaye, James Brown, Jimi Hendrix, Little Walter, Jimmy Reed, Robert Lockwood Jr., Willie "Big Eyes" Smith, and Pinetop Perkins. Born in Jackson, Mississippi, in 1942, he learned to play drums as a teenager in juke joints around his hometown.

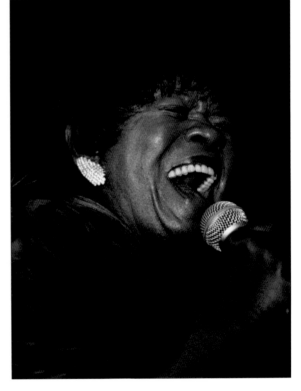

KOKO TAYLOR, CHICAGO, 2000. Koko Taylor, "the Queen of the Blues," belted out a raw, heavy Chicago blues in the tradition of Big Mama Thornton, Bessie Smith, and Ma Rainey. Born to sharecroppers as Cora Walton in Bartlett, Tennessee, in 1929, her first exposure to music was gospel. She moved to Chicago in 1953, where she sat in with Muddy Waters and Howlin' Wolf. Willie Dixon brought her to Chess Records, where her version of his song "Wang Dang Doodle" was an R&B hit in 1966.

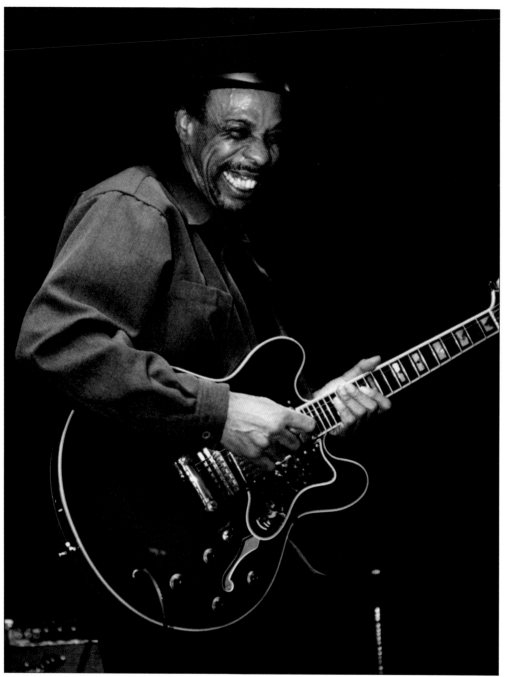

JOHN PRIMER, CLEVELAND, OHIO, 2000. With a nod to the classic 1950s Chicago tradition, John Primer is a leading architect in contemporary Chicago blues. Born in 1945 in Camden, Mississippi, he moved to Chicago in 1963. Influenced by Sammy Lawhorn, Jimmy Reed, B.B. King, Albert King, and Elmore James, he played guitar in bands with Willie Dixon and Muddy Waters. An accomplished slide guitarist, he was a member of Magic Slim and the Teardrops for 14 years before embarking on a solo career. His first two solo albums, *Stuff You Got to Watch* and *The Real Deal*, are chock-full of traditional Chicago blues.

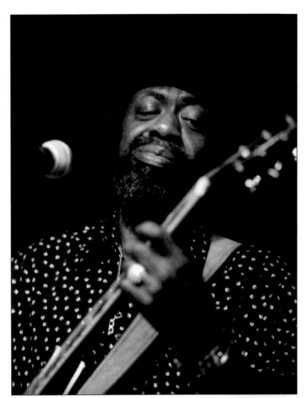

SON SEALS, CLEVELAND, OHIO, 2000, AND POCONO BLUES FESTIVAL, 1999. Son Seals combined a hard-driving, searing guitar with raw-edged vocals, making him a mainstay in modern Chicago blues. Frank "Son" Seals, born in 1942 in Osceola, Arkansas, became immersed at an early age in the blues. Albert King, Robert Nighthawk, and Sonny Boy Williamson all played at his father's juke joint in Arkansas. On arrival in Chicago in the 1960s, he played with Junior Wells, James Cotton, Buddy Guy, and Hound Dog Taylor. He toured with Albert King, a huge influence on his playing, and was inspired by the West Side blues of Magic Sam and Fenton Robinson. Seals took over Taylor's regular weekend gigs at the Expressway Lounge on Chicago's South Side. *Midnight Son*, his second album from 1976, established him as a major blues artist.

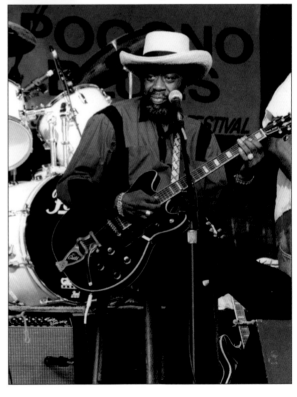

EDDIE SHAW, CLEVELAND, OHIO, 2000 (RIGHT), AND CHICAGO BLUES FESTIVAL, 1999. Eddie Shaw was a stand-out saxophone player in the world of guitar-oriented blues. His big tenor R&B sound was heard in Chicago bands with Muddy Waters, Howlin' Wolf, Freddie King, Magic Sam, and Otis Rush. Born on a plantation in 1937 in Stringtown, he grew up in Greenville, working in bands with Elmore James, Ike Turner, and Little Milton. Muddy Waters saw him play in Itta Bena and urged him to relocate to Chicago in 1957. He was a major blues attraction in the United States and Europe in the 1980s through the 2000s.

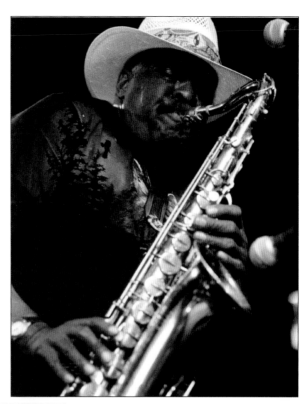

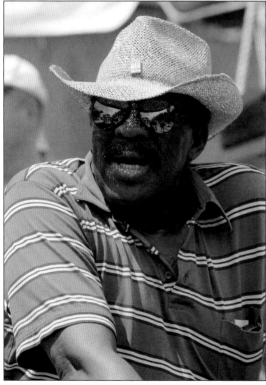

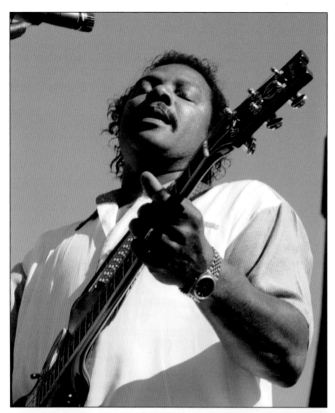

LONNIE SHIELDS, CHICAGO BLUES FESTIVAL, 1999 (LEFT), AND CLEVELAND, OHIO, 2000. Lonnie Shields infuses a soulful, rhythmic spin on contemporary blues. Born in West Helena, Arkansas, in 1956, his early influences were gospel, soul, and R&B. He was introduced to traditional Delta blues by Sam Carr in Lula, Mississippi, along with mentors Frank Frost and Big Jack Johnson of the Jelly Roll Kings. He gained notice on *Portrait*, his first album in 1993, and continues to perform in the United States, Europe, and Canada.

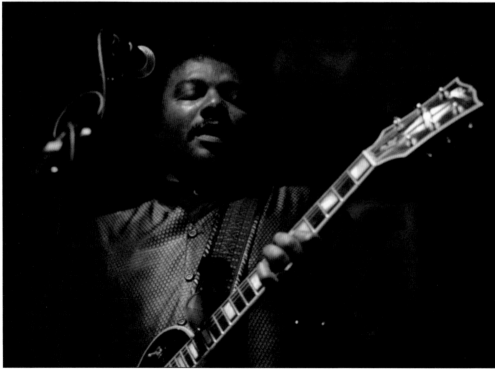

ROBERT "BILBO" WALKER, CHICAGO, 2000.
Robert "Bilbo" Walker was a flamboyant blues
musician, with roots in rock, soul, and Delta
blues. Born in 1937 on the Borden Plantation
in Clarksdale, his sound pays homage to
early rock and roll and Delta juke joint blues.
His primary influences were Muddy Waters,
Sam Cooke, Chuck Berry, and Ike Turner.
He opened Wonderlight City, an authentic
juke joint, near Clarksdale in 2016.

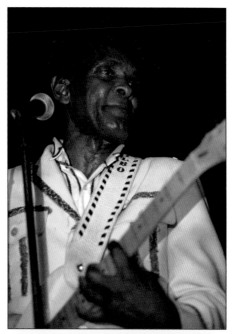

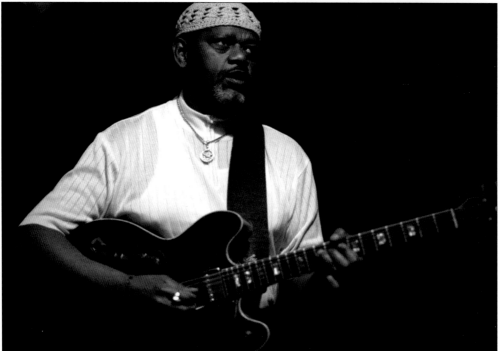

JOHNNIE B. MOORE, CLEVELAND, OHIO, 2000. Johnnie B. Moore injects the Delta tradition into
a contemporary West Side Chicago blues sound. Moore played in Koko Taylor's Blues Machine
in the mid-1970s as well as in Willie Dixon's band. Born in 1950 in Clarksdale, he sang in gospel
groups and was taught by his Baptist minister father, Floyd Moore. Influenced by Magic Sam
and Muddy Waters, he played with Jimmy Reed as a teenager in Chicago. His first album, *Hard
Times*, was released in 1987.

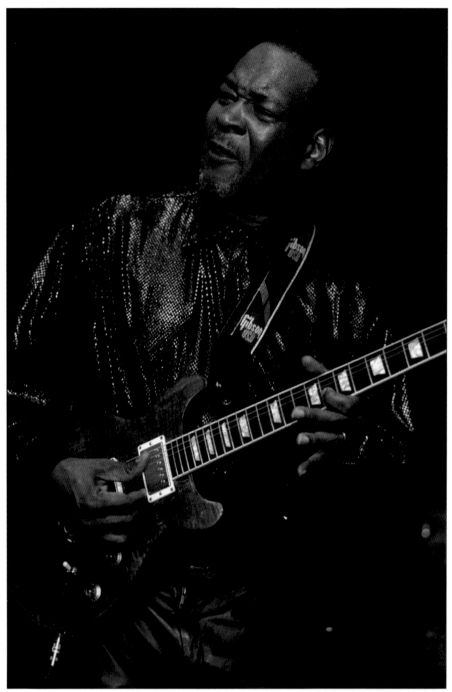

CARL WEATHERSBY, CLEVELAND, OHIO, 1998. Carl Weathersby places a contemporary spin on Chicago blues, with a mix of soulful vocals and classic blues guitar. Born in Meadville, Mississippi, in 1953, he moved to Chicago at the age of eight but returned to Mississippi in the summers, where he became immersed in blues and R&B. He played for short road trips with Albert King and is best known for his 14-year stint in Billy Branch's Sons of Blues. *Don't Lay Your Blues On Me* launched his solo career in 1996.

Three
MISSISSIPPI DELTA VIEWS

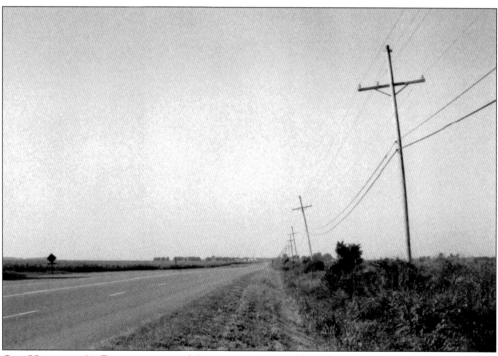

OLD HIGHWAY 61, ROBINSONVILLE, MISSISSIPPI, 2016. Old Highway 61 in the Mississippi Delta, known as "the Blues Highway," is one of America's most famous routes. It was heavily traveled during the Great Migration of African Americans from the South to Chicago, Detroit, St. Louis, and other Northern cities in the mid-20th century. Many early blues songs included references to Highway 61. The current road is located to the east of the old highway.

DELTA SUNRISE, TUNICA, MISSISSIPPI, 2016. The Mississippi Delta is a rich alluvial plain perfectly suited for growing cotton and other crops. Created through regular flooding over the centuries between the Mississippi and Yazoo Rivers, the Delta contains some of the most fertile soil deposits in the world.

MISSISSIPPI RIVER, MEMPHIS, 2016. The Mississippi River is forever linked to the legacy of the the Delta. For over two centuries, levees have been created on the river to help prevent flooding in the lower Mississippi valley. The Great Mississippi Flood of 1927, immortalized by Charley Patton's "High Water Everywhere," was among the most destructive in US history. As a result, the world's largest system of levees and floodways were built.

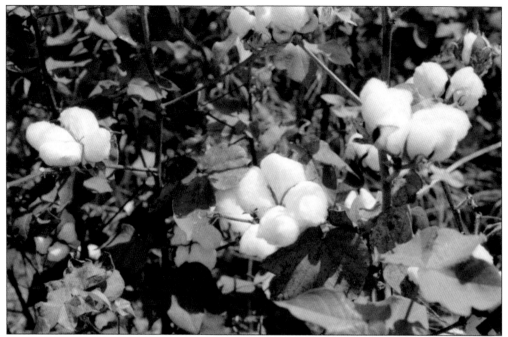

COTTON FIELDS, TUNICA COUNTY AND LEFLORE COUNTY, MISSISSIPPI, 2016. Cotton farming and the Mississippi Delta remain synonymous. For over two centuries, cotton has been grown here. By the early-19th century, "King Cotton" was already a premier crop. Following the Civil War, sharecropping and tenant farming became a way of life for African Americans. With the mechanization of farming in the 1920s and 1930s, the need for manual labor was greatly reduced, causing the Great Migration to the North. Although cotton is still a major commodity in Mississippi, it has been replaced by soybeans, rice, and corn as the top agricultural crops.

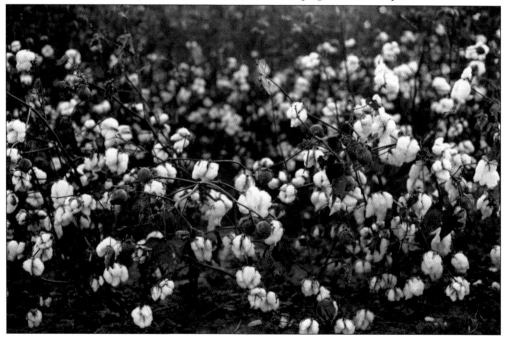

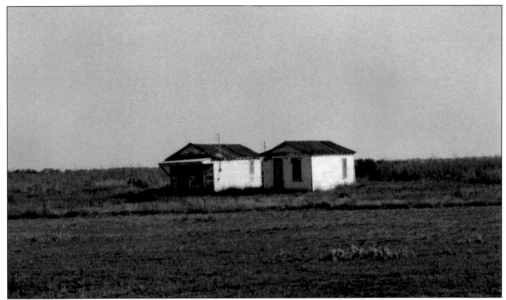

Sharecropper Shacks, Belzoni and Quito, Mississippi, 2016. The rich, fertile soil of the Mississippi Delta was well-suited for sharecropping and tenant farming. Sharecropping was a system of working on land owned by plantation landlords for a share of the yield. The landlord owned the land, cabins, tools, seeds, and equipment to grow the crops. Sharecroppers owned practically nothing. In return for their work, tenants received a share of the money for selling the crops. Unfair business contracts between tenants and landlords kept sharecroppers in a constant state of poverty, with high-interest rates, over-priced company stores, and strict labor practices. Sharecropping declined in the mid-20th century with the advent of mechanized farming. Many workers migrated to Northern cities for factory work.

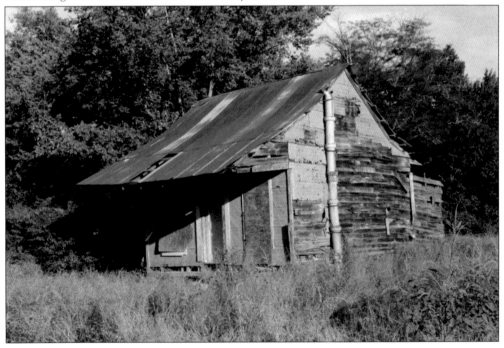

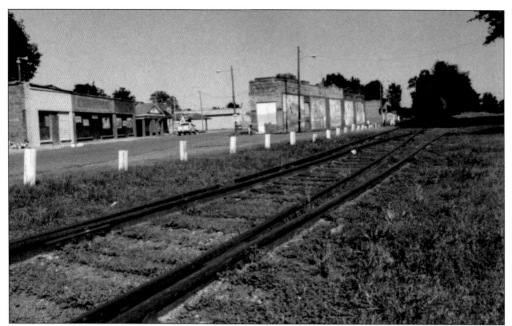

TUTWILER, MISSISSIPPI, 2016. Tutwiler stakes claim as "Birthplace of the Blues." Located on Highway 49, in Tallahatchie County, the town is where composer W.C. Handy first heard a blues song being played in 1903. While waiting at the Tutwiler railway depot for a train to Memphis, Handy describes "the weirdest music I ever heard" as being played by a black man on a guitar using a knife. The line was from the song "Goin' Where the Southern Cross the Dog," referring to a perpendicular crossing of the Southern Railroad and the Yazoo & Mississippi Valley Railroad (Y&MV) in Moorhead. The Y&MV, also known as the Yazoo Delta, is nicknamed the "Yellow Dog." After moving to Memphis, Handy became "the Father of the Blues" with blues-adapted compositions, including "Yellow Dog Blues," "Beale Street Blues" and "St. Louis Blues."

MOORHEAD, MISSISSIPPI, 2017. Moorhead was an important passenger and freight railway connection in the early-20th century. The intersection of the Southern Railroad and Yazoo-Delta Railroad, also known as the *Yellow Dog*, is located in this Sunflower County town. The Yazoo Delta became the Yazoo & Mississippi Valley Railroad in 1900. This crossing inspired W.C. Handy's "Yellow Dog Blues" from 1914. Handy first heard the line "Goin' Where the Southern Cross the Dog," referring to Moorhead, played by a black guitarist at the Tutwiler railroad depot in 1903. Hotels, restaurants, and juke joints were opened in Moorhead, which made it a hotbed for blues activity. Other blues songs that include references to the *Yellow Dog* included Big Bill Broonzy's "Southern Blues," Charley Patton's "Green River," and Sam Collins's "Yellow Dog Blues."

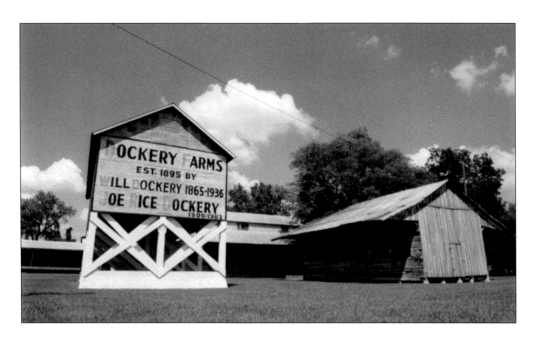

DOCKERY FARMS, SUNFLOWER COUNTY, MISSISSIPPI, 2016. Dockery Farms is considered to be the birthplace of the Delta blues. Located in Sunflower County, between Ruleville and Cleveland, the farm was founded by Will Dockery in 1895 to produce cotton. Many important blues musicians, including Robert Johnson, Howlin' Wolf (Chester Burnett), Pops Staples, Son House, and David "Honeyboy" Edwards worked and learned the blues here. Charley Patton, "the Founder of the Delta Blues," was the Dockery's most well-known resident, taught by Henry Sloan, an originator of the Delta blues style. The Dockery Farms Foundation preserves the property and historical heritage of the site.

HOPSON PLANTING COMPANY, CLARKSDALE, MISSISSIPPI, 2016. The Hopson Planting Company was the first farm to harvest cotton entirely by machine in 1944. Mechanization caused a diminished need for manual laborers, a primary reason for the Great Migration of African Americans from the South. International Harvester tested and developed tractor-mounted cotton pickers at Hopson. The technology was in turn used across the South, resulting in the end of sharecropping. Blues pianist Joe Willie "Pinetop" Perkins was a tractor driver at Hopson in the 1940s. He mentored Ike Turner on piano in Clarksdale. After leaving the Delta, he played in bands with Earl Hooker and Muddy Waters.

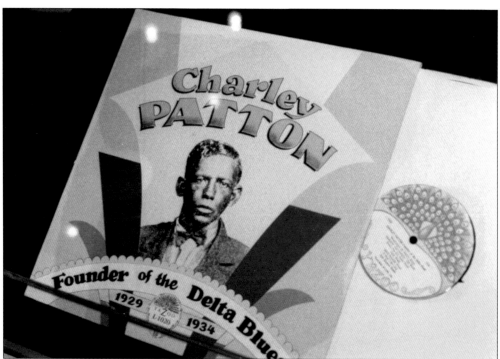

CHARLEY PATTON, GATEWAY TO THE BLUES MUSEUM, TUNICA, MISSISSIPPI, 2016. If there is one common thread in blues history, it would be Charley Patton. With his intricate guitar work and course, passionate vocals, he was the first to popularize the Delta blues. Patton lived on and around the Dockery throughout his short 43-year life, recording 57 songs between 1929 and 1934. His influence was felt by Howlin' Wolf, Robert Johnson, Son House, and Bob Dylan.

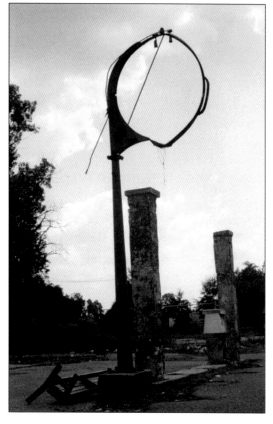

LULA, MISSISSIPPI, 2016. Once a thriving blues community in Coahoma County, Lula was home to Charley Patton and Son House in the 1930s. Patton mentions Lula in "Dry Well Blues" from 1930 and "Stone Pony Blues" from 1934. Frank Frost, of the Delta's celebrated Jelly Roll Kings, lived in Lula in the 1960s.

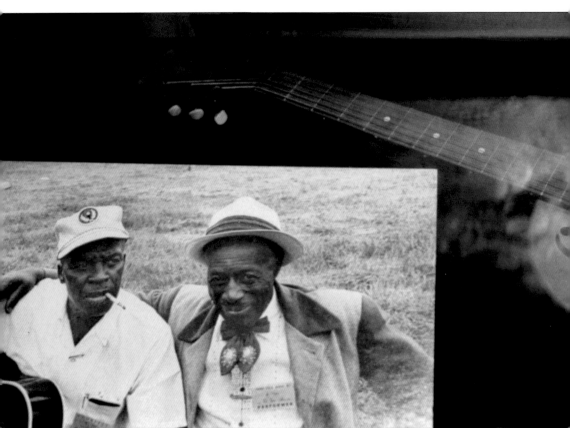

Son House and Skip James, Gateway to the Blues Museum, Tunica, Mississippi, 2016. James Eddie "Son" House, pictured on the right, is regarded as one of the blues' greatest performers. Born in Coahoma County in 1902, he lived in the Robinsonville-Lake Courmorant area of Tunica County in the 1930s and early 1940s. He was a major influence on Robert Johnson and Muddy Waters. A preacher as well as a bluesman, House gained international recognition as a part of the blues revival of the 1960s. Skip James, pictured on the left, was among the earliest and most influential musicians in the Delta to record. He was a practitioner of the Bentonia school of blues. His minor-key playing and haunting falsetto vocals were an influence of Robert Johnson's "Hellhound on My Trail" from 1937, which is an adaptation of James's "Devil Got My Woman." Eric Clapton covered James's "I'm So Glad" on Cream's debut album in 1966. James recorded on Paramount in the early 1930s, but the Depression forced him out of the blues until his "rediscovery" as part of the 1960s blues revival. (Inset photograph by Dick Waterman.)

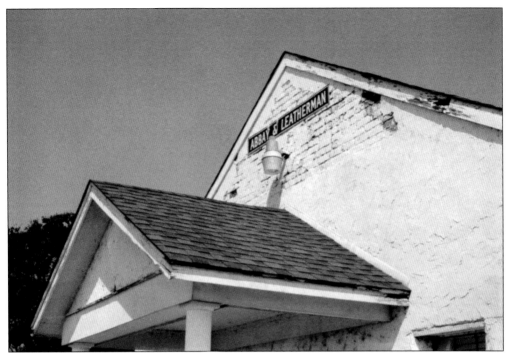

ABBAY & LEATHERMAN, ROBINSONVILLE, MISSISSIPPI, 2016. Abbay & Leatherman, in Tunica County, is one of the oldest and largest cotton plantations in the Delta. The farm was best known as the boyhood home of blues legend Robert Johnson, where he lived with his family in a tenant shack in the 1920s. During this time period, Johnson played guitar with limited skills. He left Robinsonville around 1930 for his hometown of Hazlehurst, in Copiah County, reappearing in the Delta about two years later with formidable playing abilities.

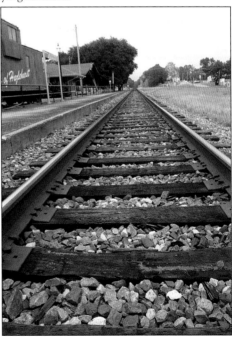

HAZLEHURST, MISSISSIPPI, 2017. Hazlehurst is best known in blues history as the birthplace of Robert Johnson. Located south of Jackson, outside the Mississippi Delta, the town is where Johnson was born in 1911. He moved to the northern Delta town of Robinsonville as a child. He returned to Hazlehurst in the early 1930s, where he learned from local blues guitarist Ike Zinnerman, who was originally from Alabama.

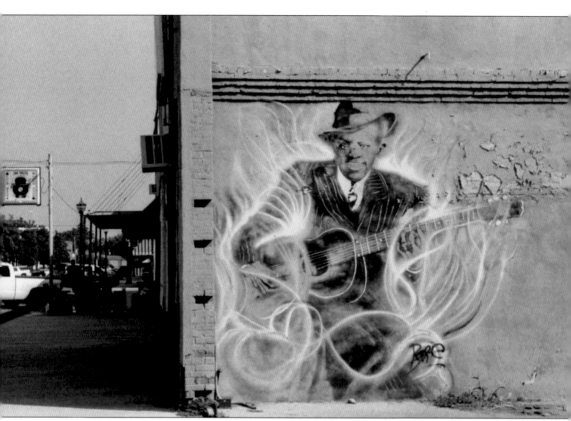

ROBERT JOHNSON MURAL, CLARKSDALE, MISSISSIPPI, 2016. Robert Johnson created the template for modern blues with his sophisticated songwriting and polyrhythmic playing style. Known as the "King of the Delta Blues," he wrote 29 blues standards, including "Sweet Home Chicago, "Come On In My Kitchen," "Walkin' Blues," "Cross Road Blues" and "I Believe I'll Dust My Broom." A life shrouded in mystery, Johnson was born in 1911 in Hazlehurst and is believed to have died from poisoning in 1938 at a juke joint in Greenwood at age 27. He is a charter member in both the Blues Hall of Fame in 1980 and the Rock and Roll Hall of Fame in 1986.

CLARKSDALE, MISSISSIPPI, 2016.
Located at the intersection of Highways 61 and 49, Clarksdale is the epicenter of the Delta blues. Clarksdale's central location in Coahoma County made it a breeding ground for blues, jazz, and ragtime. The New World district was the vibrant African American business district where blues was performed on streets, in juke joints, and at the train station. The city was birthplace to Ike Turner, Junior Parker, Son House, Jackie Brenston, and Willie Brown. Muddy Waters lived at the nearby Stovall Plantation. W.C. Handy lived in Clarksdale when he had his first encounter with the blues at the Tutwiler depot.

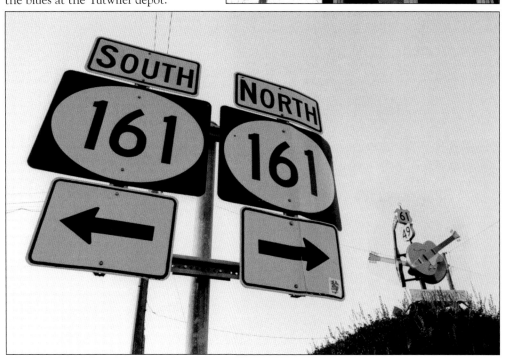

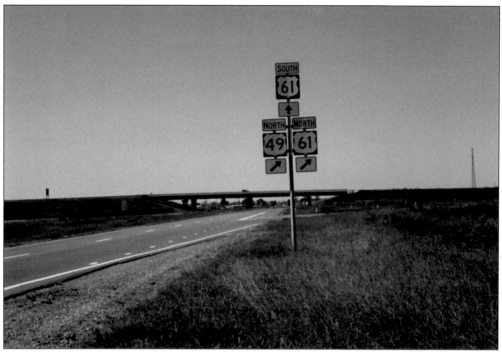

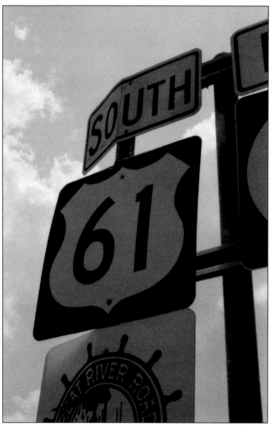

HIGHWAY 61 SIGNS, CLARKSDALE AND TUNICA, MISSISSIPPI, 2016. Highway 61 in Mississippi, known as "the Blues Highway," reaches mythic proportions in Delta blues folklore. It was a heavily traveled route by migrant workers and blues musicians during the Great Migration of African Americans to the North. The original road, located to the west of the current route, stretches from New Orleans to Minnesota. Highway 61 passes through Natchez, Vicksburg, Leland, Cleveland, Clarksdale, Tunica, and Memphis. Blues songs about the iconic road have been recorded by Sunnyland Slim, Son Thomas, Honeyboy Edwards, Big Joe Williams, and Mississippi Fred McDowell. Blues musicians who lived near Highway 61 included Charley Patton, Robert Johnson, Son House, Muddy Waters, B.B. King, Howlin' Wolf, Sonny Boy Williamson II, Ike Turner, Sunnyland Slim, Honeyboy Edwards, James Cotton, Jimmy Reed, and Junior Parker. *Highway 61 Revisited*, the classic album by Bob Dylan, brought the legendary road into rock music consciousness in 1965.

HELENA, ARKANSAS, 2016. Helena was a flourishing Mississippi River blues town from the 1930s to 1950s. The city had a reputation as being "wide-open," attracting field and riverboat workers with the lure of gambling, liquor, and juke joints. The launch of *King Biscuit Time* in 1941 on KFFA radio in Helena, with Sonny Boy Williamson II, and Robert Lockwood Jr., was the first time live blues was broadcast in the Delta region. The show was an early influence on B.B King, Jimmy Reed, Albert King, and Muddy Waters. A rotating list of blues greats, including James "Peck" Curtis, Pinetop Perkins, Willie Love, Houston Stackhouse, and Elmore James, all played on the show. Musicians who called Helena home included Robert Johnson, Sonny Boy Williamson II, Honeyboy Edwards, James Cotton, Pinetop Perkins, Robert Lockwood Jr., Roosevelt Sykes, Robert Nighthawk, and Frank Frost. The annual King Biscuit Blues Festival continues the Helena blues tradition.

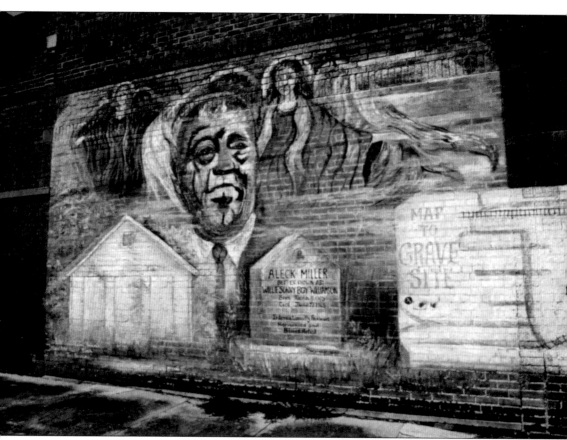

Sonny Boy Williamson Mural, Tutwiler, Mississippi, 2016. Sonny Boy Williamson II was one of the Delta's greatest musicians. Born as Aleck Miller in Glendora around 1912, he was nicknamed "Rice" at any early age. He was an associate of Robert Johnson, Elmore James, Howlin' Wolf, and Robert Lockwood Jr. His prolific harp playing influenced Junior Wells, Junior Parker, Little Walter, and British blues of the 1960s. Songs such as "Don't Start Me Talkin'," "Help Me," "Eyesight to the Blind," and "Nine Below Zero" are all standards in blues repertoire.

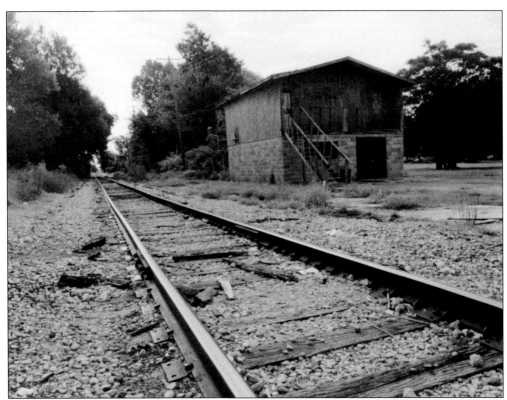

RAILROAD TRACKS, INDIANOLA AND LULA, MISSISSIPPI, 2016. The allure of the railroad culture still permeates throughout the Delta. Railroads are a common metaphor in the blues, representing the need to travel or the longing to escape to a better life. During the Great Migration, the Illinois Central Railroad was an important mainline from the South to Chicago. Notable songs with railroad themes included Charley Patton's "Peavine Blues," Robert Johnson's "Traveling Riverside Blues," Big Bill Broonzy's "Southbound Train," and Junior Parker's "Mystery Train." Railroads remain a quintessential image in the Delta, with the sound of the blues still ringing through the tracks.

COUNTRY CHURCH, LEFLORE COUNTY, MISSISSIPPI, 2016. Gospel music was a major influence on the blues. The relationship between church music and the blues is intertwined, both closely relating to the same experiences in black culture. Many gospel songs were turned into early blues by changing the lyrics. The long list of blues performers who started their musical foundation in the church included B.B. King, Charley Patton, Son House, Muddy Waters, Mississippi Fred McDowell, and John Lee Hooker.

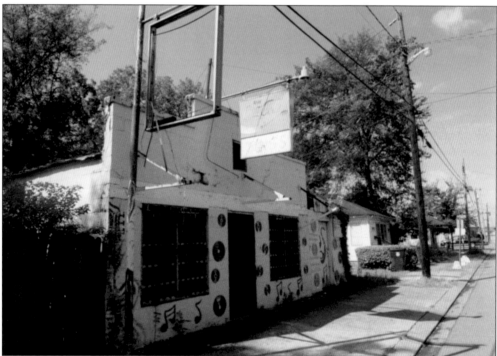

BAPTIST TOWN, GREENWOOD, MISSISSIPPI, 2017. Baptist Town is one of Greenwood's oldest African American neighborhoods. Robert Johnson and Honeyboy Edwards lived in and out of Baptist Town, known as a safe haven for musicians who wanted to escape work in the cotton fields, according to Edwards. Johnson was allegedly poisoned in a juke joint just outside of Greenwood and spent some of his final days on Young Street in Baptist Town, before he died on August 16, 1938 at the Star of the West Plantation. Tommy McClennan was also a prominent bluesman based in Greenwood.

GREENWOOD, MISSISSIPPI, 2016. Located on the eastern edge of the Delta, Greenwood was known as the "Cotton Capital of the World." The Yazoo River, which forms in Greenwood at the confluence of the Tallahatchie and Yalobusha Rivers, made it a prime shipping center, connecting the city to the Mississippi River ports of Vicksburg, New Orleans, and St. Louis. Although cotton demand has been replaced by corn and soybean, Greenwood is the second largest US cotton exchange. Robert Johnson spent time in Greenwood's Baptist Town. He was poisoned at a juke joint in Greenwood in 1938, with his "official" gravesite at Little Zion M.B. Church, located north of town. Notable bluesmen born in Greenwood included Furry Lewis, Hubert Sumlin, and Guitar Slim. Greenwood was a center for the civil rights movement in the 1960s.

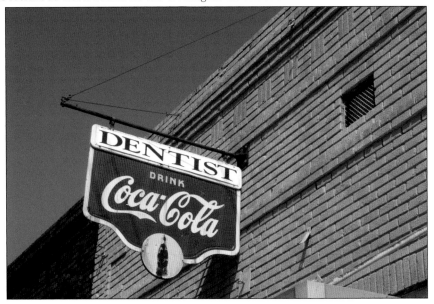

DELTA CROSSROADS, SUNFLOWER COUNTY, MISSISSIPPI, 2016. An archetype symbol in the blues, the Delta crossroads is the elusive point where myth and reality converge. This is where the legend of the itinerant bluesman making a deal with the devil for prowess in the blues begins. It is here that the crossroads becomes a metaphor for choices made in life.

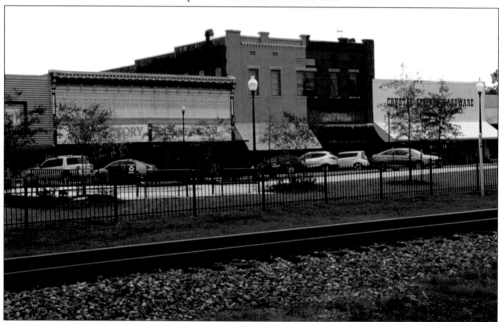

CRYSTAL SPRINGS, MISSISSIPPI, 2017. Located in Copiah County, Crystal Springs was childhood home to early blues pioneer Tommy Johnson. He was born on a plantation between Crystal Springs and Terry and is buried at Warm Springs Methodist Church cemetery north of town. His distinctive and influential falsetto voice is heard on "Canned Heat Blues," "Big Road Blues," and "Cool Drink of Water Blues." Johnson played in the Delta with Charley Patton and in Jackson with Rubin Lacy, Charlie McCoy, and Walter Vinson.

ROSEDALE, MISSISSIPPI, 2016. Rosedale is immortalized by references in Robert Johnson's "Traveling Riverside Blues" from 1937 and Eric Clapton's version of "Crossroads" with Cream from 1968. Located on Highway 1 in Bolivar County, Rosedale was a wide-open riverfront town known for gambling, liquor, and juke joints. The Riverside division of the Yazoo & Mississippi Valley Railroad, which ran from Memphis to Vicksburg, made stops in Rosedale, Friars Point, and other locations. Delta blues great Charley Patton also mentions Rosedale in his 1929 recording "High Water Everywhere," an account of the Great Mississippi River flood of 1927. Johnson also extolled the popularity of hot tamales in the Delta with "They're Red Hot" from 1937.

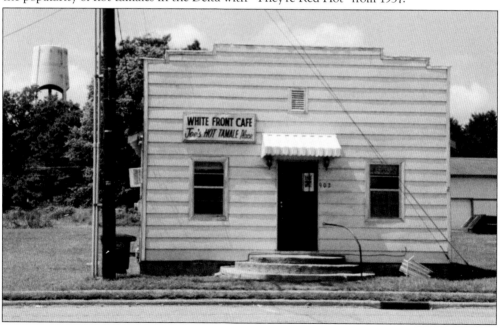

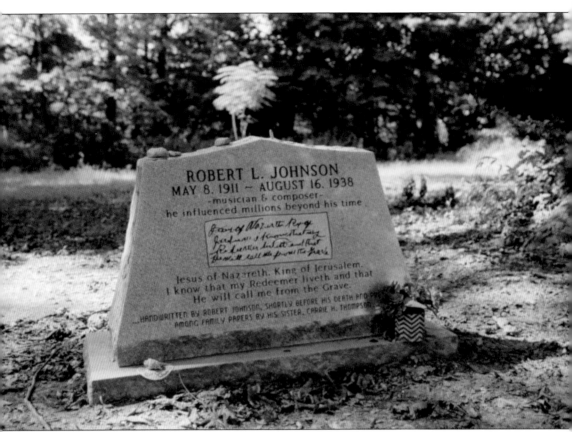

ROBERT JOHNSON GRAVESITE, GREENWOOD, MISSISSIPPI, 2016. In life, Robert Johnson was a mystery, and in death, he is an enigma. The blues' most celebrated figure is believed to have been poisoned by the owner of the Three Forks juke joint outside Greenwood in August 1938. According to an eyewitness of Johnson's burial, the Little Zion M.B. Church, north of Greenwood, is considered the "official" gravesite. A grave marker was placed at the site in 2002.

ROBERT JOHNSON MARKERS, MORGAN CITY AND QUITO, MISSISSIPPI, 2016. Just as there is no definitive proof of what killed Robert Johnson, so too is the uncertainty of where he is buried. Johnson was first believed to have been buried at Mount Zion M.B. Church in Morgan City. The exact spot at the church was not known. A cenotaph monument was placed by the Mt. Zion Memorial Fund, through a grant by Columbia Records, in 1991 at the graveyard. In 1990, *Living Blues* magazine identified Payne Chapel M.B. Church, in nearby Quito, as the unmarked burial site. A Georgia-based rock band, the Tombstones, placed a marker near the supposed spot. However, the State of Mississippi recognizes Little Zion M.B. Church, north of Greenwood, as his final resting place.

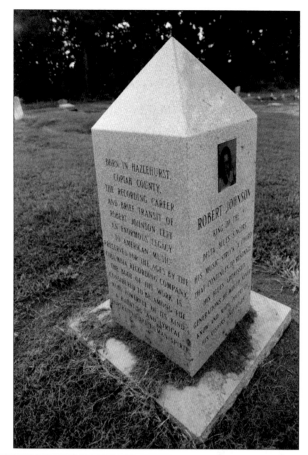

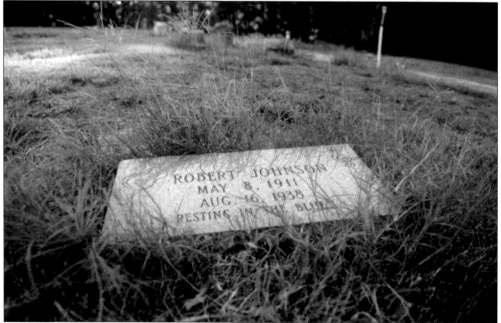

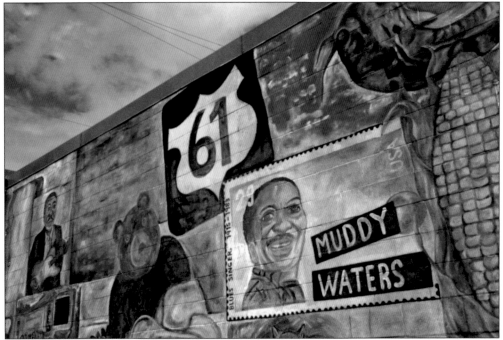

ROLLING FORK AND SHARKEY COUNTY, MISSISSIPPI, 2017. Muddy Waters, born as McKinley Morganfield, was one of the most important and influential figures in blues history. He took the deep Delta blues tradition and transformed it into the electric Chicago blues style. Songs such as "Rollin' and Tumblin'," Mannish Boy," "Trouble No More," and "Got My Mojo Working" virtually created the modern blues sound and pointed the way for rock and roll in the 1950s. Waters claimed Rolling Fork in Sharkey County as his birthplace in 1915, although it is more likely he was born in Jug's Corner in neighboring Issaquena County in 1913 or 1914. His grandmother gave him the nickname Muddy on the Cottonwood plantation in Mayersville because he loved to play in the mud.

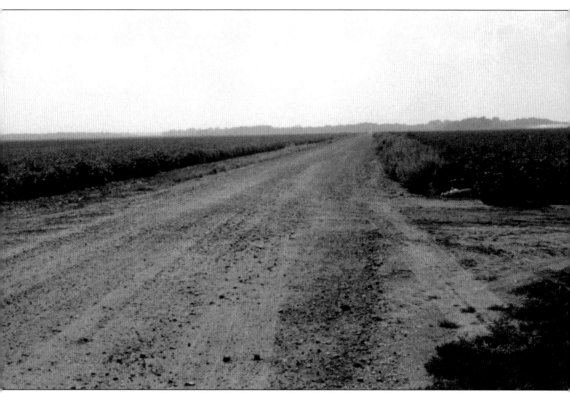

STOVALL FARMS, COAHOMA COUNTY, MISSISSIPPI, 2016. Muddy Waters moved to Stovall plantation, near Clarksdale, as a child, where he was raised by his grandmother. His early blues influences were Son House, Robert Johnson, and Robert Nighthawk. He performed with his mentor, Big Joe Williams. Waters was recorded by Alan Lomax for the Library of Congress at his Stovall cabin in 1941. The cabin is on display at the Delta Blues Museum in Clarksdale. This is the view of Stovall Farms from Waters's former cabin location.

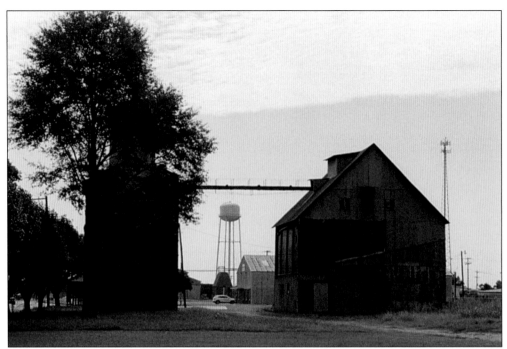

INDIANOLA, MISSISSIPPI, 2016. Indianola claims the honor of being B.B. King's hometown. Born on a river bank in Berclair near Itta Bena, King lived in Kilmichael and Lexington as a child, before moving to Indianola in his teens. He always claimed Indianola as his adopted hometown. Centrally located in the middle of the Delta in Sunflower County, Indianola has a long agricultural history in cotton, corn, soybean, and catfish. Church Street was the African American business district during the segregation era. A young B.B. King played here for tips on the street in the early 1940s. Notable bluesmen Robert Nighthawk, Robert Lockwood Jr., and the big bands of Count Basie and Duke Ellington played at Church Street night spots. The B.B. King Museum and Delta Interpretive Center opened in 2008.

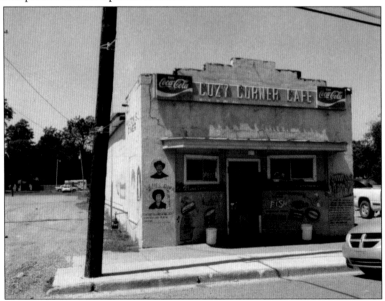

B.B. King's Corner, Indianola, Mississippi, 2016. When a young Riley B. King was not at work in the cotton fields, he would play guitar on the streets of Indianola. His favorite spot was the corner of Church Street and Second Street, centrally located between the white and black business districts. He made more in tips playing the blues than religious songs.

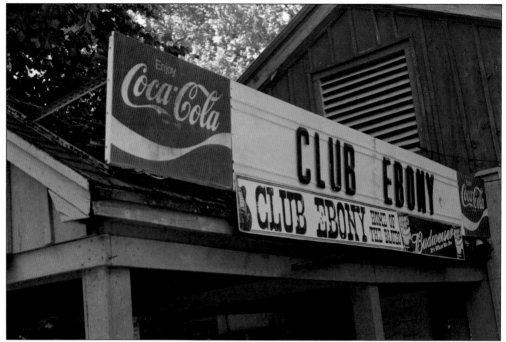

CLUB EBONY, INDIANOLA, MISSISSIPPI, 2016. Club Ebony was one of the South's most important African American venues. Opened in 1948 by Johnny Jones, the club was a showcase for B.B. King, Albert King, Little Milton, Bobby Bland, Willie Clayton, and many other famous performers. In 1975, the club was purchased by Willie and Mary Shepard and was a stop on the "chitlin circuit" for James Brown, Ike Turner, Syl Johnson, Clarence Carter, Denise LaSalle, Bobby Rush, Howlin' Wolf, and Tyrone Davis. B.B. King purchased the club in 2008, preserving it as a cultural landmark.

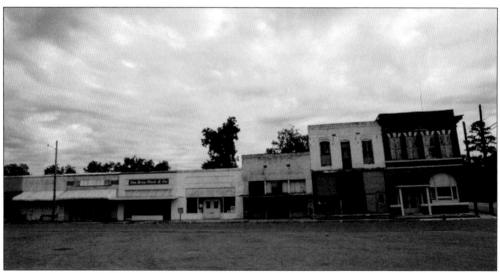

ITTA BENA, MISSISSIPPI, 2017. Itta Bena was once a thriving agricultural community in Leflore County. Today, the town is a long row of shuttered storefronts. B.B. King was born in nearby Berclair to sharecroppers in a shack on Bear Creek. Mississippi Valley State University, located in Itta Bena, hosts an annual B.B. King Day symposium.

BEALE STREET, MEMPHIS, 2016. Memphis was a hotbed for blues activity in the first half of the 20th century. Many blues musicians from Mississippi migrated to Memphis to perform on Beale Street, also known as the "Main Street of Black America." Beale served as a launching pad for many blues players to be heard beyond the Delta. W.C. Handy first popularized the blues with "Memphis Blues" in 1912 and "Beale Street Blues" in 1916. Mississippi musicians who moved to Memphis after World War II included B.B. King, Rufus Thomas, and Junior Parker. Thomas and King both worked at WDIA radio in the late 1940s, where King became known as "Beale Street Blues Boy," or B.B. for short. Memphis was the soul music capital in the 1960s with Stax and Hi Records. Stax artists from Mississippi included Albert King, Little Milton, Pops Staples, and Rufus Thomas.

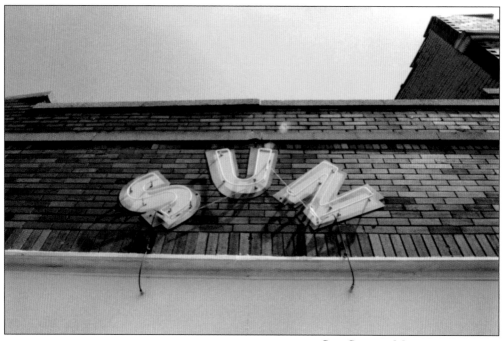

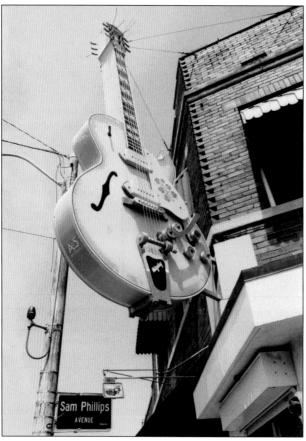

SUN STUDIO, MEMPHIS, 2016.
Sun Records was the starting point in recording for many of Mississippi's top blues musicians. The list includes B.B. King, Howlin' Wolf, Junior Parker, Little Milton, James Cotton, and Rufus Thomas. Sam Phillips opened Memphis Recording Services in search of raw, unfiltered blues and R&B in 1950. "Rocket 88," by Jackie Brenston and Ike Turner's Kings of Rhythm, recorded here in 1951, is often considered the first rock-and-roll record. Elvis Presley's first Sun single, "That's All Right," infused elements of blues and country in 1954. "That's All Right," written by blues artist Arthur "Big Boy" Crudup, of Forest, Mississippi, was first released in 1946. The early Sun recordings by Johnny Cash, Carl Perkins, Jerry Lee Lewis, Roy Orbison, and Charlie Rich are all milestones in popular music. Sun Records became Sun Studio in 1987.

INVERNESS, MISSISSIPPI, 2016. Located on Highway 49 West in Sunflower County, Inverness was the birthplace of Blues Hall of Famer Little Milton Campbell and Chicago bassist Willie Kent. Campbell was born on the George Bowles plantation but spent most of his childhood in Washington County. Kent worked on his mother's sharecropping farm, where he was exposed to blues and gospel. He left home for Memphis at age 13, migrating to Chicago at 16.

JIMMY REED'S BIRTHPLACE, DUNLEITH, MISSISSIPPI, 2016. Jimmy Reed was one of the first and most successful blues artists to "crossover" to R&B, rock, and pop audiences. His relaxed blues style appealed to both black and white crowds, with hit singles that included "Bright Lights, Big City," "Big Boss Man," "Honest I Do," and "Baby What You Want Me To Do." Born in 1925 at the Shady Dell plantation in Dunleith in Washington County, he worked in the fields at Shady

Dell and McMurchy Plantations, near Duncan. Childhood friend Eddie Taylor taught him guitar, and the two teamed up in Chicago's South Side. Reed achieved mainstream pop success in the mid-1950s and early 1960s, before B.B. King and Muddy Waters. He was inducted into the Blues Hall of Fame in 1980 and the Rock and Roll Hall of Fame in 1991.

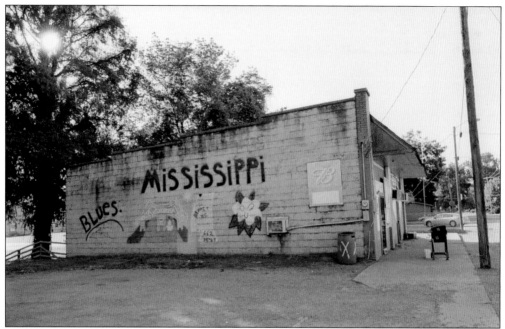

BENOIT, MISSISSIPPI, 2016. Benoit was the birthplace of Chicago blues sax player Eddie Shaw and guitarist Eddie Taylor. Shaw was born on a plantation in nearby Stringtown. Other blues greats from Bolivar County included Big Bill Broonzy, Honeyboy Edwards, Henry Townsend, Otis Clay, Eddie C. Campbell, Peck Curtis, and Wade Walton.

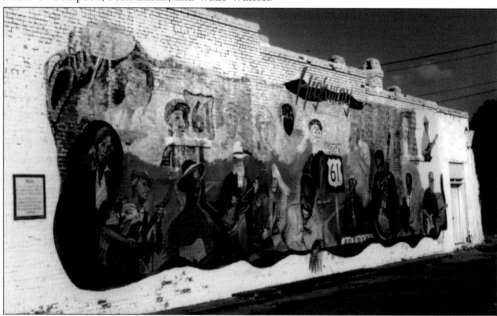

LELAND, MISSISSIPPI, 2016. Leland is one of the most celebrated towns on Highway 61. Located in the heart of the Delta, Leland and Washington County remain an important cotton-producing region. Several Leland murals depict blues musicians with origins in the area, including Sam Chatmon, Little Milton, James "Son" Thomas, Eddie Cusic, Johnny Winter, and Edgar Winter. Johnny Winter's "Leland Mississippi Blues," from his 1969 debut album, pays homage to his Delta roots.

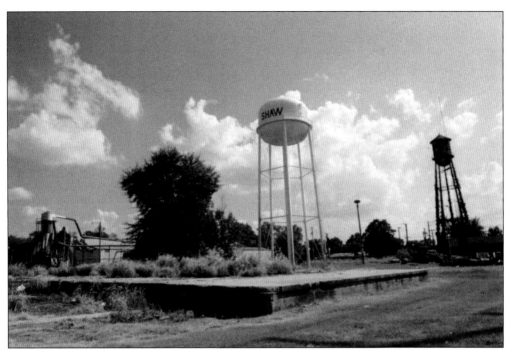

SHAW, MISSISSIPPI, 2016. Located on Highway 61 in both Bolivar and Sunflower Counties, Shaw was the birthplace of Delta blues exponent David "Honeyboy" Edwards in 1915. Born to a sharecropping family, Edwards witnessed Delta blues pioneers Charley Patton and Tommy Johnson play at his plantation. He traveled with many of the early blues greats, including Big Joe Williams, Tommy McClennan, and Robert Johnson. He was recorded for the Library of Congress by Alan Lomax in 1942 in Clarksdale.

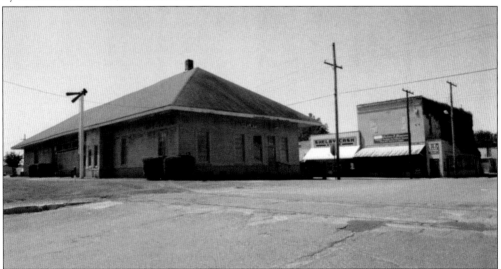

SHELBY, MISSISSIPPI, 2016. Shelby is a historical blues town located on Highway 61 in Bolivar County. Henry Townsend, the only blues artist to have recorded in every decade from the 1920s into the 2000s, was born in Shelby in 1909. The town was also home to Erma Franklin, Hattie Littles, Walter "Choker" Campbell, and Gerald Wilson. The old Shelby Depot, built for the Yazoo & Mississippi Valley Railroad in 1901, is shown in this photograph.

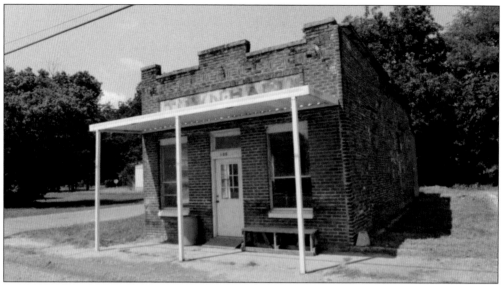

DUNCAN, MISSISSIPPI, 2016. The small town of Duncan, located on Highway 61 in Bolivar County, was the home or birthplace of several notable blues performers. Chicago bluesman Eddie C. Campbell was born in Duncan in 1939. Blues great Jimmy Reed lived on the nearby McMurchy Plantation in his youth. Other prominent Delta musicians born in Duncan were pianist Willie Love and Ernest Lane, a member of Ike Turner's Kings of Rhythm.

DREW, MISSISSIPPI, 2016. With close proximity to the Dockery plantation in Sunflower County, Drew was a blues center in the 1920s. Charley Patton and Willie Brown played in area jukes and on street corners. Tommy Johnson developed his Delta style in Drew before returning to Jackson. Roebuck "Pops" Staples lived with his family at the Dockery, where he was inspired by Patton and Howlin' Wolf, who often performed in Drew.

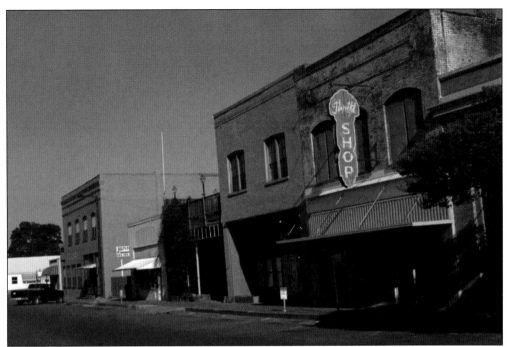

BELZONI, MISSISSIPPI, 2016. Belzoni is a historical blues and civil rights town on Highway 49 W, located on the Yazoo River, in Humphries County. Blues pianist Joe Willie "Pinetop" Perkins was born on a plantation near Belzoni. Soul and blues star Denise LaSalle spent much of her childhood here. Turner's Drug Store and the Easy Pay Store were among the first sponsors of radio programs in Mississippi to feature Delta blues in the late 1940s.

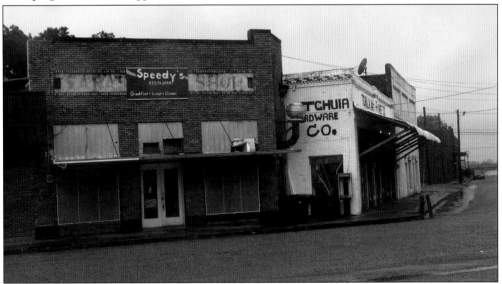

TCHULA, MISSISSIPPI, 2017. Tchula was once a thriving blues hub during the segregation era but has fallen on hard times since. The once-thriving cotton community disappeared with farm mechanization. Located on Highway 49 East in Holmes County, blues performers who lived in the area included Jimmy Dawkins, Elmore James, Hound Dog Taylor, Lester Davenport, and Little Smokey Smothers.

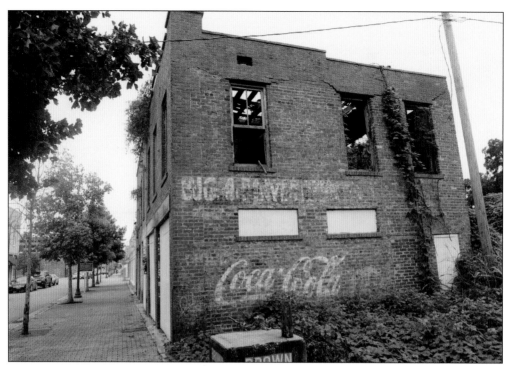

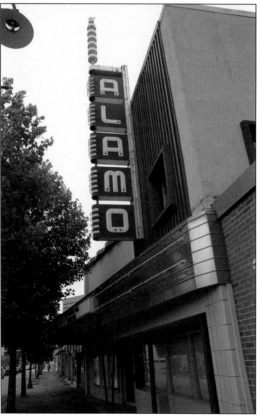

FARISH STREET, JACKSON, MISSISSIPPI, 2017. Jackson, the state capital, is a long-standing center for blues culture and history. Farish Street was the main African American business district. Henry Speir, owner of the Speir Phonograph Company, was an early blues talent scout. Charley Patton and Skip James were among his finds, and he presented Robert Johnson's name to ARC Records, who recorded Johnson in San Antonio in 1936. Ace, Trumpet, and Malaco Records were important Jackson blues and R&B labels. The King Edward Hotel was the recording site of the Mississippi Sheiks in 1930s, and the Alamo Theater was an important showcase for blues and jazz in the 1940s and 1950s. Jackson is hometown to Bobby Rush, Otis Spann, and Dorothy Moore. Jackson was pivotal in the civil rights movement of the 1950s and 1960s. The Mississippi Civil Rights Museum was opened in the city in 2017.

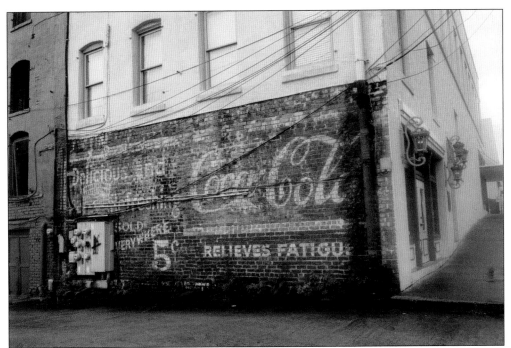

McCOMB. MISSISSIPPI, 2017. Rock and roll originator Bo Diddley was born in 1928 in Magnolia, just south of McComb, near the Louisiana border. Born Ellas McDaniel, his distinctive beat and rhythm and pioneering use of distortion was an influence on Eric Clapton, Jimi Hendrix, the Rolling Stones, Link Wray, and the Who. He lived his early years in Pike and Amite Counties. He played the violin before taking up guitar at age 12 in Chicago.

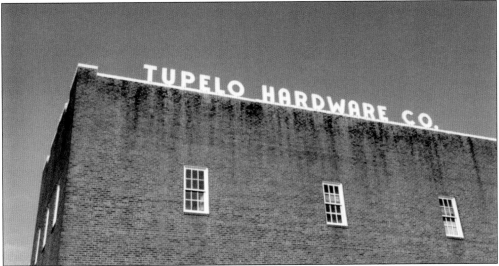

TUPELO, MISSISSIPPI, 2017. Tupelo's blues connection is most famous for the influence on Elvis Presley, who lived adjacent to the African American neighborhoods of Shake Rag and On the Hill. Presley infused blues, country, and gospel he heard as a youth in Tupelo into early rock and roll. His first single, "That's All Right," released on Sun Records in 1954, was a cover of Arthur "Big Boy" Crudup's 1946 record. His mother, Gladys, bought his first guitar in 1946 at Tupelo Hardware.

VICKSBURG, MISSISSIPPI, 2017. The historic Mississippi River town of Vicksburg was the birthplace of blues songwriter Willie Dixon in 1915. He spent his formative years writing songs in Vicksburg before moving to Chicago. As a popular session man for Muddy Waters, Howlin' Wolf, Little Walter, Bo Diddley, and Otis Rush, his songwriting credits included "Hoochie Coochie Man," "Spoonful," "Little Red Rooster," and "I Ain't Superstitious." British bands who covered his songs in the 1960s included the Rolling Stones, Cream, Jeff Beck, and Led Zeppelin.

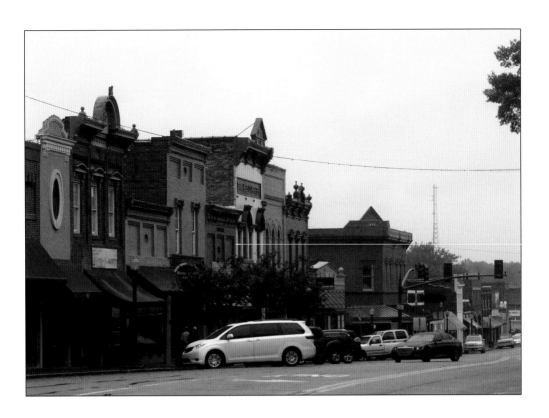

CANTON, MISSISSIPPI, 2017. Canton, located in the central part of the state in Madison County, was once a prominent blues hub. Slide guitar innovator Elmore James was Canton's most well-known blues musician. He played in "The Hollow," the social, business, and entertainment district for the African American community. James learned about electronics while working at a radio repair shop, which led him to develop an original electric blues style. Blues performers including B.B. King, Howlin' Wolf, and Sonny Boy Williamson II also performed here.

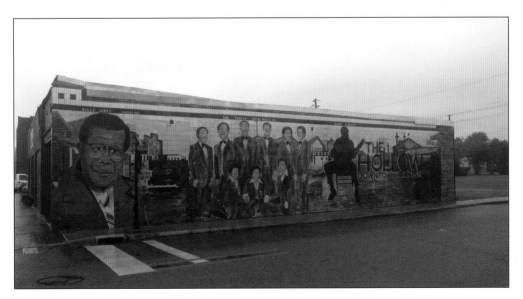

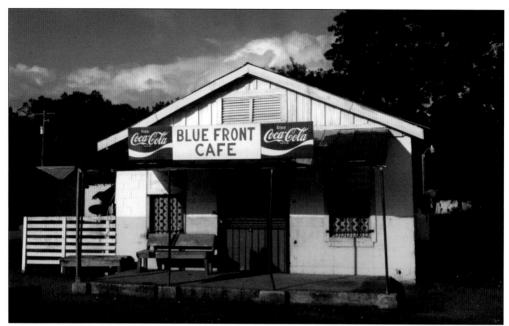

Blue Front Café, Bentonia (Above), and Yazoo City, Mississippi, 2017. Bentonia blues differs from the Delta and Hill Country blues with its use of poignant, minor-key melodies. Located in Yazoo County in the southeast corner of the Delta, Bentonia was isolated from the central Delta's influence, which led to the region's unique blues phrasing. The Blue Front Café, owned by Jimmy "Duck" Holmes, was opened in 1948 by his parents Carey and Mary Holmes and is the oldest surviving juke joint in Mississippi. The café was originally a gathering spot for field workers from Yazoo County. Notables who played at the Blue Front included Skip James, Jack Owens, Henry Stuckey, Sonny Boy Williamson II, and James "Son" Thomas. Skip James, a major figure in Bentonia blues, with "Hard Times Killing Floor," and "Devil Got My Woman," was an influence on Robert Johnson.

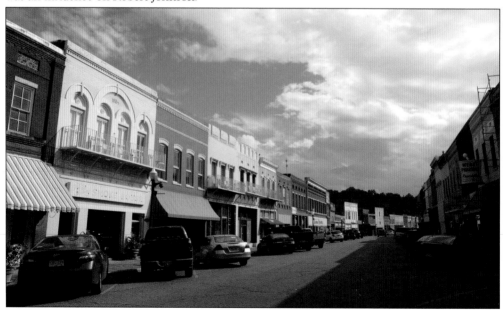

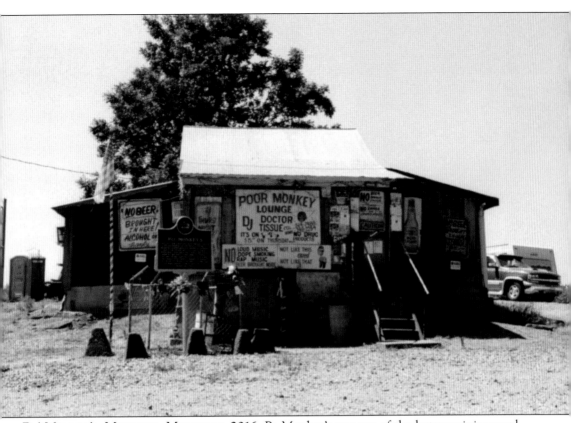

Po' Monkey's, Merigold, Mississippi, 2016. Po Monkey's was one of the last remaining rural juke joints in Mississippi to survive into the 21st century. Located on a winding, gravel country road on a cotton field in Bolivar County, Po' Monkey's hearkens back to the days when country jukes were in abundance. Willie "Po Monkey" Seaberry opened the spot in an old sharecropper shack to locals in 1963. It became popular with students and as a destination point for blues tourists in the 1990s. Seaberry passed away in 2016.

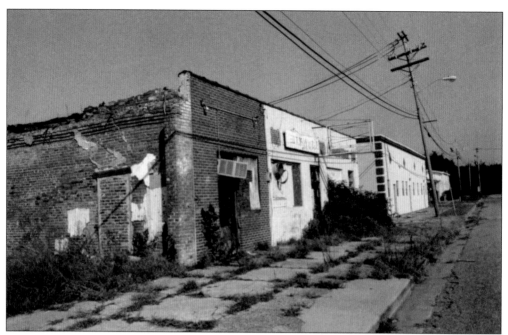

RED TOP LOUNGE AND MESSENGERS CLUB, CLARKSDALE, MISSISSIPPI, 2016. The Red Top Lounge, the remains of which are in the above photograph, was Clarkdale's main blues spot for decades. The Jelly Roll Kings, with Big Jack Johnson, Frank Frost, and Sam Carr, were the house band. The Messengers Club, founded by Edward Messenger, which had a liquor license as early as 1907 or 1908, was one of Clarksdale's first African American businesses. Messengers is considered to be Clarksdale's oldest continuously running business. Ground Zero Blues Club and Red's Blues Club are the town's current primary blues venues.

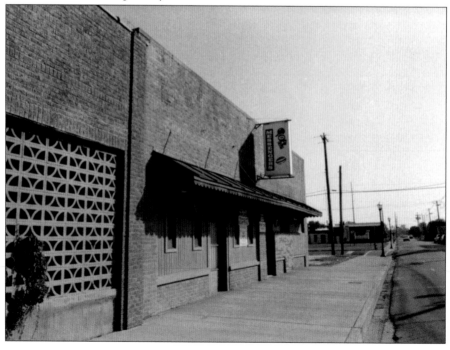

VANCE, MISSISSIPPI, 2016. John Lee Hooker, born somewhere between Clarksdale and Vance, spent his formative years in the Delta. He worked in the cotton fields around Vance and Lambert before he moved to Detroit, with stays in Memphis and Cincinnati, in the 1940s. Hooker's cousin, blues guitarist Earl Hooker, was also from the Vance area. Blues pianist Sunnyland Slim was born in Vance. Chicago bluesmen with Quitman County roots included Snooky Pryor and Jimmy Rogers and county natives Big Jack Johnson, James "Super Chikan" Johnson, and Johnnie Billington.

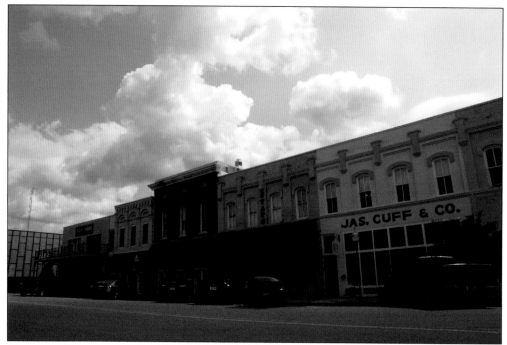

GRENADA, MISSISSIPPI, 2017. Situated midway between Memphis and Jackson, Grenada has a lengthy blues tradition. Grenada County was home to "Magic Sam" Maghett, Morris "Magic Slim" Holt, Big George Brock, and Eddie Willis. Magic Sam, an architect of Chicago's West Side sound, began his performing career in Grenada before he moved to Chicago in the early 1950s. Memphis musicians with Grenada roots also included William Brown, who recorded for the Library of Congress in 1942, and Bukka White, who once lived on a Grenada farm.

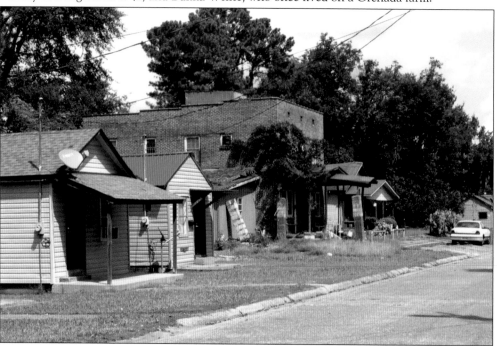

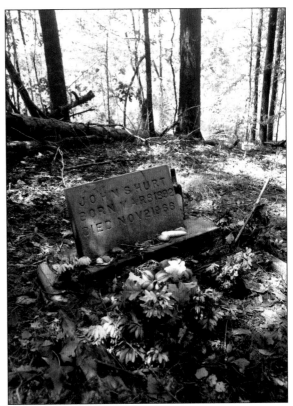

JOHN HURT GRAVESITE, CARROLL COUNTY (ABOVE), AND VALLEY, MISSISSIPPI, 2017. A central figure in the blues revival of the 1960s, Mississippi John Hurt lived most of his life farming and playing country blues around Avalon and Carroll County. He made his first recordings in 1928 in Memphis. He recorded "Avalon Blues," a song about missing his hometown, later that year in New York. It took another 35 years for his "rediscovery" in 1963, when he became a favorite on the blues festival circuit. He is buried in St. James Cemetery, located in the remote, wooded countryside of Carroll County. The abandoned Valley Store, a spot where Hurt would perform, remains a remnant of a time that once was.

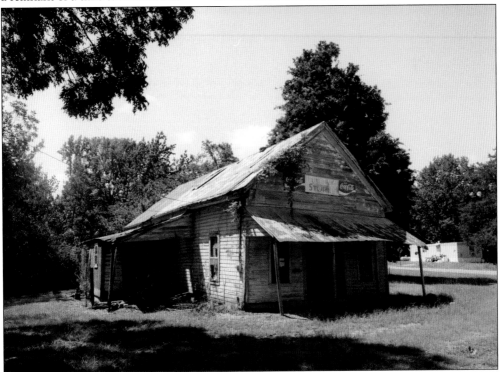

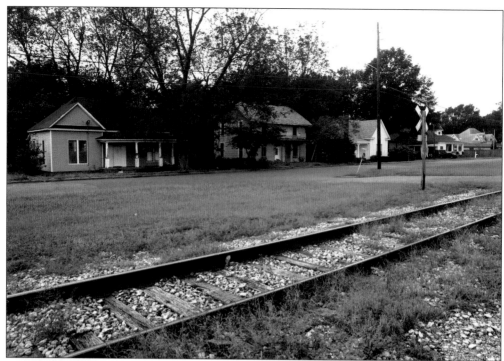

SARDIS, MISSISSIPPI, 2017. The life of a traveling bluesman in the Delta of the 1930s was filled with many perils. Robert Lockwood Jr. and Sonny Boy Williamson II were incarcerated for vagrancy in Sardis around 1935. While in jail, they would play from their cell, and people would throw coins onto the jail grounds. Realizing the profit potential, the high sheriff allowed them to play on the streets during their 21-day sentence. The jailers would keep the tip money and return the prisoners to their cell with hotel food and whiskey.

COMO, MISSISSIPPI, 2017. Located in Panola County, Como was home to many North Mississippi hill country blues musicians. Similar yet distinctive from Delta blues, hill country blues is known for droning, haunting grooves. Bluesmen from Como included Mississippi Fred McDowell, a seminal figure in Mississippi hill country blues; Otha Turner, an exponent of the fife and drum tradition in north Mississippi; and Napolian Strickland, also in the fife and drum and country blues traditions.

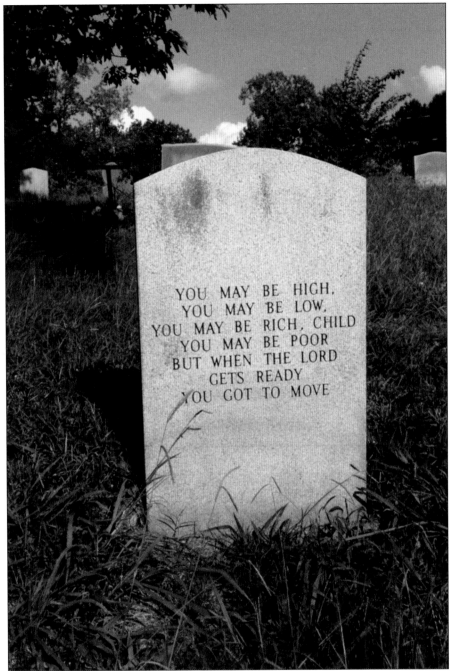

YOU MAY BE HIGH,
YOU MAY BE LOW,
YOU MAY BE RICH, CHILD
YOU MAY BE POOR
BUT WHEN THE LORD
GETS READY
YOU GOT TO MOVE

FRED MCDOWELL GRAVESITE, COMO, MISSISSIPPI, 2017. "Mississippi" Fred McDowell lived most of his life in Como where he played authentic Delta country blues. McDowell was discovered and recorded by Alan Lomax in 1959 and became part of the 1960s blues revival. His memorial stone, located at Hammond Hill M.B. Church cemetery near Como, was installed by the Mt. Zion Memorial Fund in 1993. A line from his song "You Got To Move" is inscribed on the back side of the gravestone. The original marker, with his name misspelled and damaged, is on display at the Delta Blues Museum in Clarksdale.

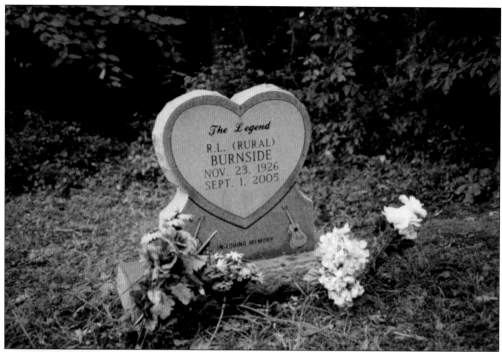

R.L. BURNSIDE GRAVESITE, HARMONTOWN, MISSISSIPPI, 2017. R.L. Burnside was a forerunner of the distinctive North Mississippi hill country blues. Burnside, born in Harmontown, made his home in nearby Holly Springs of Marshall County. He is buried in Free Springs CME Church cemetery in rural Harmontown, of Lafayette County.

SUNSET, HOLLY SPRINGS, MISSISSIPPI, 2017. The blues is uniquely American music. Within the blues structure and rhythms, there is a universality that reaches beyond cultural, ethnic, or religious differences. The blues faces adversity head on and remains triumphant over injustice and inequality. Although distinctive to the African American experience, the blues strikes a chord of commonality within us all.

BIBLIOGRAPHY

Bogdanov, Vladimir, Chris Woodstra, and Stephen Thomas. Erlewine, eds. *All Music Guide to the Blues: The Experts' Guide to the Best Blues Recordings (2nd Ed)*. San Francisco: Backbeat Books, 1999.

Cheseborough, Steve. *Blues Traveling, The Holy Sites of Delta Blues, Third Edition,* Jackson: University of Mississippi Press, 2009.

Herzhaft, Gerard. *Encyclopedia of the Blues,* Fayetteville: University of Arkansas Press, 1997.

Gioia, Ted. *Delta Blues, The Life and Times of the Mississippi Masters Who Revolutionized American Music,* New York: W.W. Norton and Company, Inc., 2008.

Lomax, Alan. *The Land Where the Blues Began,* New York: The New Press, 1993.

Palmer, Robert, *Deep Blues,* New York: Penguin Books, 1982.

Santelli, Robert, *The Big Book of the Blues*, New York: Penguin Books, 1993.

DISCOVER THOUSANDS OF LOCAL HISTORY BOOKS FEATURING MILLIONS OF VINTAGE IMAGES

Arcadia Publishing, the leading local history publisher in the United States, is committed to making history accessible and meaningful through publishing books that celebrate and preserve the heritage of America's people and places.

Find more books like this at
www.arcadiapublishing.com

Search for your hometown history, your old stomping grounds, and even your favorite sports team.

Consistent with our mission to preserve history on a local level, this book was printed in South Carolina on American-made paper and manufactured entirely in the United States. Products carrying the accredited Forest Stewardship Council (FSC) label are printed on 100 percent FSC-certified paper.

MADE IN THE USA